GLASS HANDBOOKS

MOULD MAKING
FOR GLASS

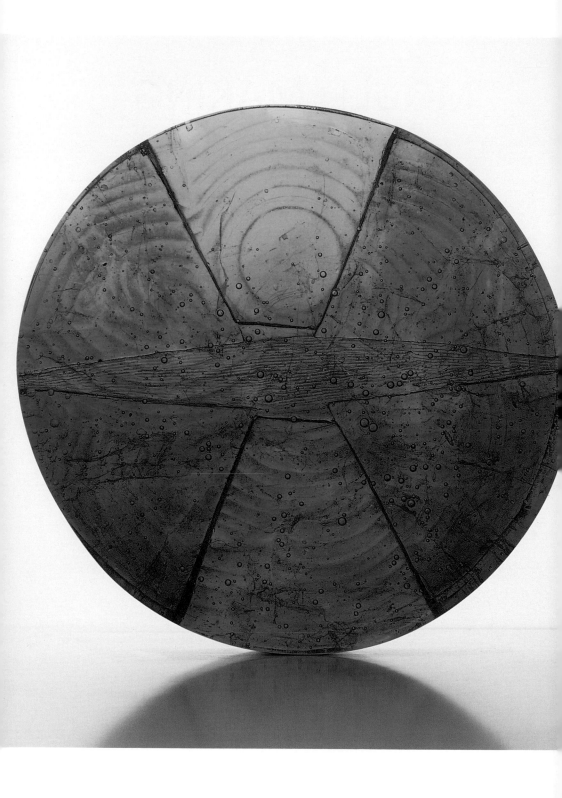

GLASS HANDBOOKS

MOULD MAKING FOR GLASS

Angela Thwaites

BLOOMSBURY

LONDON · NEW DELHI · NEW YORK · SYDNEY

Acknowledgements

Writing this book has been both fulfilling and pleasurable in a way I had not fully expected. I have gained great satisfaction in bringing together the work of a diverse range of artists for whom I have immense respect and admiration.

I would therefore like to give my sincere thanks to all who responded so positively with information and images which have extended my research and facilitated the production of this book.

My thanks to the Bodrum Underwater Archaeology Museum and the Uluburun Shipwreck Project (INA) for their permission to include images of historic kiln formed glass in their collection.

Special thanks are due to Jaroslava Brychtova for her enthusiastic permission to include works made by herself and her late husband Stanislav Libensky.

There are many more fine examples of kiln formed glass which I would have liked to include and much more I could have written, so I sincerely hope that other opportunities for research and writing will arise in the future.

I am also very grateful to Alison Hawkes at A&C Black for her support and encouragement throughout.

First published in Great Britain 2011
Bloomsbury Publishing
50 Bedford Square, London WC1B 3DP
www.bloomsbury.com

ISBN: 978-14081-1433-9

Reprinted 2012, 2013

Copyright © 2011 Angela Thwaites

A CIP catalogue record for this book is available from the British Library.

Cover design: James Watson
Page design: Susan McIntyre
Commissioning editor: Alison Stace

Typeset in: 10 on 12.5pt Photina

This book is produced using paper that is made from wood grown in managed, sustainable forests. It is natural, renewable and recyclable. The logging and manufacturing processes conform to the environmental regulations of the country of origin.

Printed and bound in China.

FRONTISPIECE: Sun, by Angela Thwaites. Open-cast from clay model, dia: approx. 25cm (10in). Photo by Robert Taylor.

CONTENTS

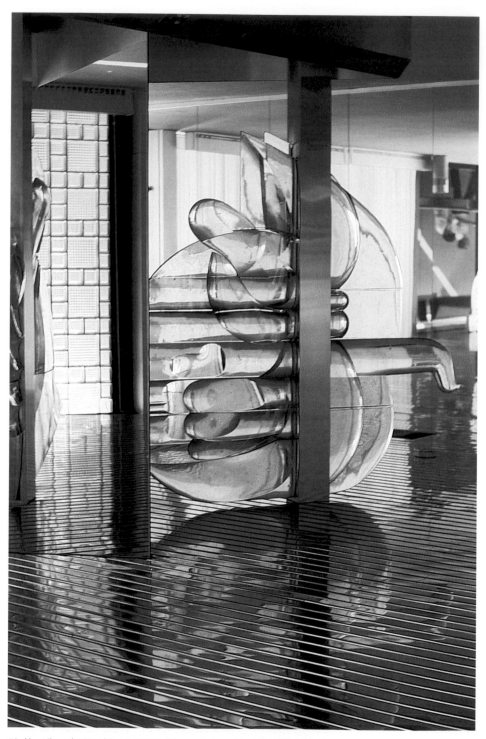

Bird by Libenský/Brychtová, 1978. Kiln-cast glass, ht: 2.9m (9ft 6in). Photo by Angela Thwaites.

INTRODUCTION

In 1981 I visited the Corning Museum of Glass in New York State, and what I saw there changed my life. In the entrance to the museum were massive sculptures by Stanislav Libenský and Jaroslava Brychtová from Czechoslovakia, as it was then. Standing nearly three metres high, each was made in kiln-cast glass in one or two vast sections, held in a steel base. I was 21 years old and just about to start the final year of my degree course, and experiencing the scale and presence of these enormous glass sculptures fundamentally impacted on my own ideas and aspirations.

Just over a year later I had secured funding to go to Prague to study with Professor Libenský, determined to find out how to make kiln-cast glass on this monumental scale.

Even now, after years of building on my educational experiences I am still experimenting with all aspects of how to work with kiln-formed glass, and continue to learn on a daily basis whether that be in my own studio or working with students on university and adult-education courses and summer academies.

My own learning also developed significantly through taking part in a research project between 1999 and 2001, funded by the Arts and Humanities Research Council, at the Royal College of Art in London. The project focused on materials and mould-making methods for glass casting in contemporary practice. The findings of this project were shared through conferences and as a CD-ROM entitled 'Mixing with the Best'. Although all the material in this book is newly written, my aim is to continue the spirit of 'Mixing with the Best' by showcasing the work of emerging as well as established practitioners.

Discussion with other practitioners is a vital way of learning and sharing practical and technical information. I would like to thank all of those who have generously provided me with images and details of their practice for this book, which aims to give some starting points for kiln-forming, and particularly kiln-casting, glass.

A brief description of kiln-formed glass

Kiln-forming glass covers a wide range of techniques, materials, processes and approaches to creating art and craft works using glass as the main material and the heat of a kiln as the main method of forming.

The principal areas of kiln-forming can be defined as kiln-casting (often referred to as mould-melting), as well as slumping, fusing and pâte de verre. Under each of these headings, there

Cast-glass beads, 1st Century AD, found near Kizilağaç Kayirli, Bodrum, dia: 1–1.5cm (approx. ½in). Photo by Angela Thwaites taken at the Bodrum Underwater Archaeology Museum, Bodrum, Turkey.

is still a broad range of methods and ways of applying materials, and an even wider range of results.

It is worth saying at this point that most, if not all, of these techniques have their roots in ancient history, some as early as 4000 years ago. Visits to the British and Victoria and Albert Museums in London, Broadfield House in Stourbridge, the National Glass Centre in Sunderland, and the Musée D'Orsay and Musée des Arts Decoratif in Paris will give access to plenty of examples and information on the development of kiln-formed glass over time.

A visit to Corning Museum of Glass in New York State is also a must for serious glassmakers, as it has probably the most extensive glass collection and archive in the world, including both historic and contemporary pieces (see also Further reading, p.134).

Iteration 456 by Shelley Doolan, 2010. Cast from a model made by rapid protoyping.
Photo by Simon Bruntnell.

Socrates II by Angela Thwaites, 2004. Cast Banas glass, ht: approx. 48cm (19in). Photo by Robert Taylor.

KILN-CASTING GLASS

A simple definition
(see also Glossary)

A basic definition of kiln-casting glass could be melting glass into a mould to create a desired form using a kiln as the heat source. Kiln-casting exploits many of the most appealing characteristics of glass, including its fluidity, its optical qualities, its potential for detail and colour, and its responses to light. The techniques described in this book show how it is possible to work creatively with all of these qualities.

The kiln-casting process starts with making a model and involves making a mould from materials that are able to withstand high heat; this is called a refractory mould. Glass is loaded into the mould, which is then placed in a kiln and heated up to the point where the glass melts into the exact shape and detail of the inside of the mould.

Kiln-casting includes a number of related methods for forming molten glass in refractory moulds. The most basic type of casting I am calling open casting. For open casting the model is an essentially simple shape, easily removed from the refractory mould, giving a wide-open top which is easy to load with glass. This method gives a flat, fire-polished surface after firing.

Sand-casting is a method of hot pouring where molten glass is ladled out of a furnace and poured into an impression made in a specially prepared bed or box of sand, or into a preheated mould. This technique can be echoed in the kiln using sand, grog and plaster or ludo – previously fired moulds crushed and mixed with new plaster and new refractory to produce a simple form without undercuts, giving a sandy/ grainy texture to the glass. (See Chapter 3: Understanding Ingredients, and Chapter 11: Developing Your Own Recipes and Methods).

Starting points for making

Whichever method you use, you will need a model to start with, and to make this you need a starting point. This can be an idea, which you will need to work up into a model or a found object (manmade or organic).

Whether you start with an idea or an object, you will need to develop a clear view of what you want to make – the identity of the final object – and this will affect the way you make it.

Here is a list of things to think about at the beginning of the making process:

Idea/object → form → surface → scale → glass type → final surface → firing temperature & duration → model-making material & method → mould mix & method → **final object**

Positive/negative

It is vital to understand from the beginning that your original model will be called a **positive** – that is, it must be the exact form you want in glass and not the opposite – and the mould will be the **negative**. Positives and negatives can be made in a range of materials (see table below and also Chapter 5: Model and Master Mould-making).

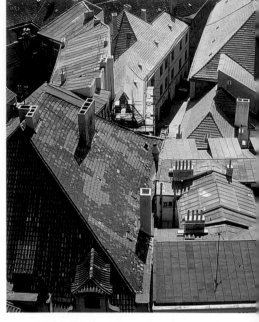

ABOVE: Rooftops in Prague Old Town.

LEFT: The clay model (positive).

BELOW: *Mala Strana* by Angela Thwaites. Cast-glass piece (positive) made in an open mould, 34 x 28 x 5.5cm (13½ x 11 x 2¼in). (See also p.37.)

Open moulds

Simple, open moulds can be made with a flat base or the side of the model placed face down on the bench. This method is suitable for the simplest shapes with little or no undercut detail, and those which can be easily removed from the mould – for example, clay models.

A key point to understand is that the face of the model which is underneath during mould-making will be the upside of the mould – the open face – during firing. The orientation of the model and the entry point for the glass therefore need to be carefully considered before you set up for mould-making.

Open mould-making methods can also be useful for larger, shallow forms, where the open side provides a large enough area for the easy and clean removal of the model. This also allows for a large volume of glass to be loaded into the mould before firing (see Chapter 6: Mould-making Methods).

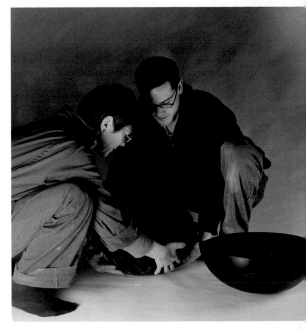

Gilles Pourtier and Angela Thwaites lifting *Dawn and Dusk*, open castings weighing about 40kg (88lb) each. Photo by Robert Taylor.

BELOW: *Dawn and Dusk* by Angela Thwaites. Castings from wax models made in open moulds using 40% lead glass, dia: (each form) 45cm (17¾in). Photo by Robert Taylor.

Witness 2 by Angela Thwaites, 1999. Open-cast from clay model, dia: approx. 25cm (10in). Photo by Robert Taylor.

Lost wax

Lost-wax casting is a well-known and popular method of casting. It gives the option of making enclosed, rather than open, refractory moulds. The lost wax or *cire perdue* method enables the casting of complex and undercut shapes with fine details and surfaces, which can be faithfully reproduced due to the sensitivity of the medium.

The wax is usually steamed or sometimes burned out of the refractory mould before glass is melted into it. This technique relates very closely to metal casting processes and can be used as a way of reproducing a number of pieces of the same shape by making a series of wax models from a durable master mould.

Wax gives greater scope than clay or other model-making materials. There are many types of wax, including soft modelling wax which can be shaped by hand for one-off pieces, or harder types (e.g. microcrystalline wax) which can be melted and poured into master moulds.

To make one-off lost-wax pieces you can follow this route:

Positive
Wax model

Negative
Refractory mould

Positive
Glass cast

Table showing positive and negative stages of making process and examples of materials for each:

Wax model (positive)	Refractory mould (negative)	Glass cast (positive)
Microcrystalline wax	Quartz/flint	Gaffer casting crystal
Modelling wax	Plaster	Bullseye patties
Dental sheet wax	Ludo	Banas Czech casting glass
	Grog	Plowden and Thompson
	Types of sand	Uroborus patties
	Molochite	Float/window glass
	Alumina	Schott 30% lead glass
	China clay	Bottle glass
	Ceramic shell mix	

(See Chapter 3: Understanding Ingredients and Chapter 10, List of Mould-mix Recipes, for details of mould mixes; and Chapter 6, Mould-making Methods for details of refractory mould making).

To make repeats you need master copies to work from. This table shows positive and negative stages and examples of potential materials for making masters. (See Chapter 5, Model and Master Mould-making.)

Master model (positive)	Master mould (negative)
Found Objects	Gelflex
Plaster	Cold-cure rubber
Clay	Plaster
Alginate	
Gelflex	
Cold-cure rubber	
Wood	
Polystyrene or foam	
Papier mâché	
Cardboard	
Plastic	

Core casting

Core casting is a method used to cast hollow objects, or forms with an internal space where one shape appears to be floating or suspended inside another.

Core casting is possibly the most complex of the kiln-forming methods, and relies on a sound understanding of model- and mould-making techniques. There is further explanation and images in Chapter 8: Core Casting.

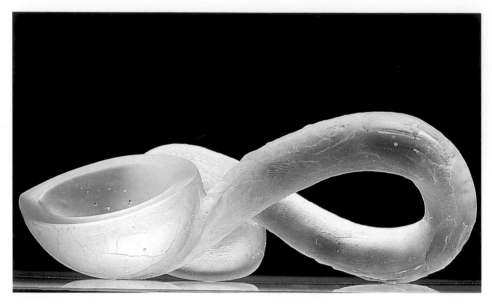

Soleares by Angela Thwaites, 1998. Cast in Dartington Crystal, l: approx. 25cm (10in), showing fine surface texture reproduced through the lost-wax process. Photo by Robert Taylor.

'Lost-vegetable' casting

This method uses an organic starting point, e.g. a small vegetable, fruit, plant, fish or piece of wood around which the refractory mould is made. The organic material is then burned out and glass melted in. Further detail and images are given in Chapter 7: Hand-building.

Larger-scale casting

All the methods of kiln-casting described above can be used to cast glass on a larger scale. In all cases, scaling up needs to be considered carefully in advance, and appropriate methods and materials selected for use according to the demands of each individual piece or project. I would always recommend beginning with a scale where you feel in control of the model- and mould-making, and check your materials beforehand – there is nothing more dispiriting than starting out and having to give up halfway through as you run out of plaster, time or energy!

My definition of 'large' is not necessarily the same as everyone else's, but it takes into account the size and weight of the mould as well as the fired/cast glass weight, and the physical strength of the maker within safe limits. So if I cannot lift or move it by myself then it definitely rates as large! This can therefore be anything over about 15–20kg (33–44lb) of mould or glass weight – which taken together will generally mean a total weight of over 30kg (66lb).

Good starting weights if you have little or no experience are between 1 and 5kg (2.2 and 11lb) of glass and about the same of mould mix.

Imprint of an Angel, drawing by Stanislav Libenský, 1996.

Clay model for *Imprint of an Angel*, by Libenský/Brychtová.

Imprint of an Angel by Libenský/Brychtová. Core-cast glass, 79 x 109cm (31 x 43in).
Photos by Angela Thwaites.

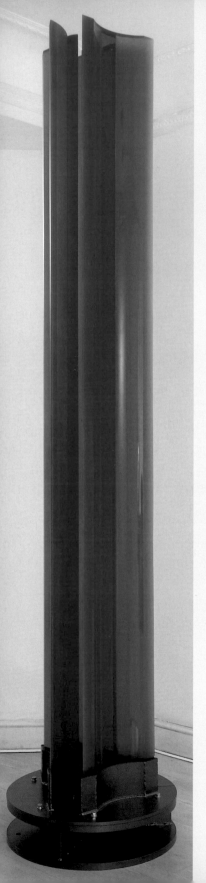

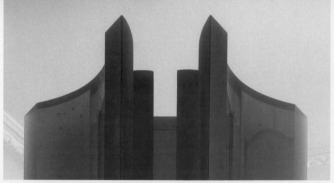

ANNA MATOUŠKOVÁ

Glass casting on a monumental scale is possible with specialist help and expertise. There are now several companies in the Czech Republic who can cast remarkably large and heavy pieces in glass. One of these studios is Lhotský s.r.o. at Pelechov, near Železný Brod, where the skill and scope of the studio and its team of workers was developed by Jaroslava Brychtová and Stanislav Libenský, beginning in the early 1950s.

Anna Matoušková, who studied with Professor Libenský, realised this piece through collaboration with Lhotský (see Further reading, p.134).

Anna describes the work and the collaborative making process:

'In 2003 we started to work on making a tall simple sculpture whose length could be accommodated in the biggest kiln in the Lhotský studio.

'The character of the piece reflects beautiful architectural elements of Gothic churches: the almost endless, elegant parallel vertical lines of its pillars. That is why it was necessary to make it in one piece without interrupting the length. The sculpture is composed from three separate, long parts, which multiplies the number of lines.

'Because a glass piece of such dimensions was never made before, we were thinking about making the smaller model in 1:3 or half scale; but we started directly with the real size. We realized that a smaller piece could not answer our questions and solve our problems – a smaller, fragile piece with reduced length would bring totally different dangers. The three parts which were made have incredible quality, with no bubbles in the edge. The "freshly made" *Column* was first exhibited at the first Collect exhibition in 2004 at the V&A in London.'

Column by Anna Matoušková, 2004, 280 x 34 x 40 cm (110 x 13½ x 16in) (glass itself 265cm/104in in one piece). Probably the longest piece of its kind, it was realised at Lhotský s.r.o. in the Czech Republic. Photos by Martin Polák.

IVANA ŠRÁMKOVÁ

Ivana Šrámková was also a student of Libenský, and creates huge cast-glass sculptures, often animals or figures, constructed from sections that fit together. These pieces weigh hundreds of kilos, so the moulds made to carry this immense weight of molten material are massive and carefully reinforced (See Chapter 6: Mould-making Methods and Chapter 7: Handbuilding).

RIGHT: *Ostrich* by Ivana Šrámková, 2000. Cast glass, ht: 160cm (63 in).

BELOW: *Zebra* by Ivana Šrámková, 2000. Cast glass, ht: 170cm (67in). Photos by Gabriel Urbánek.

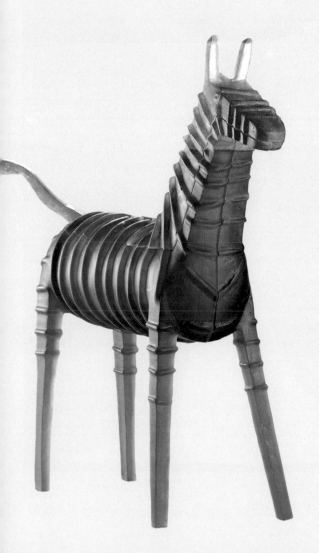

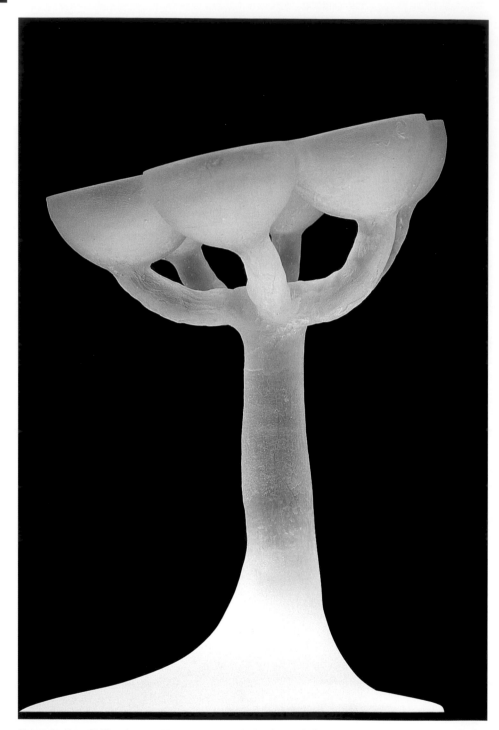

Flower by Angela Thwaites, 1999. Lost-wax cast in lead-crystal glass, ht: 50cm (20in). Photo by Robert Taylor.

WHAT IS REFRACTORY MOULD-MAKING?

Refractory investment moulds are made for kiln-forming glass using materials that will withstand high temperatures over long periods of time. They should not be confused with master moulds, which are made for recreating repeats of the same shape or form (see Chapter 5: Model and Master Mould-making).

The term 'investment' was probably first used by metal or bronze casters to refer to a mix of materials that could take and retain an accurate, detailed shape from a model. This investment mould could then be easily separated from the model, and filled with molten metal. Similar technology was later applied to forming glass in around 1500BC in Mesopotamia, Egypt, Syria and Turkey.

Refractory investment moulds are usually used only once, being destroyed during removal of the casting within them.

In this book the mixture of materials used for making investment moulds for kiln-forming glass is referred to as 'mould mix' or 'refractory mould mix' (see Chapter 11: Developing Your Own Recipes and Methods).

Functions of a refractory mould/ mould mix for glass

Refractory moulds and mould mixes need to fulfil a number of functions, some of which seem to contradict each other:

- Mould mix must be able to *take* and *retain* an accurate detailed form or shape from a model, which may be made from a range of materials, with wax, rubber, wood, clay and plaster being typical examples.
- It must be able to maintain its strength and form for extended periods of time in a kiln firing throughout the heating and cooling cycles.
- It must be easily removable from the glass without sticking to the surface of the glass or structurally damaging it.
- It must be as safe as possible in a studio environment.
- It needs to be relatively easy to make and use.
- It needs to be inexpensive as well as effective.

It is important to note that the choice of mould mix and mould construction are intrinsically linked to the kind of glass to be melted, to the top temperature and length of firing which the mould will

21

have to endure, and also to the shape and size of the object to be cast (see Chapter 6: Mould-making Methods).

Density, porosity and thickness of refractory mould mix can also seriously influence results. A dense mould mix may not be porous, so it will not shed water quickly or easily, and water content in a mould during firing and casting is usually undesirable, (see Chapter 3: Understanding Ingredients, Chapter 9: Mould-drying, Kiln-packing and Firing, and Chapter 10: List of Mould-mix Recipes). A very dense mould mix affects the weight of the mould both before and after firing. A dense and heavy mould can present real handling problems both before and after firing, when it will be full of glass and the fired mould may be just as fragile as the glass in it. A dense mould-mix body is also slow to heat up and cool down, needing greater length of firing time and therefore greater energy consumption.

The thickness of the mould mix around the model is also a consideration. If the mould wall is too thick, it can inhibit heat penetration to the inside cavity of the mould, resulting in an incomplete or failed casting (see Chapter 9: Mould-drying, Kiln-packing and Firing).

Scale is an important factor – the larger the refractory mould and the greater the weight of glass it will carry, the greater the need for mould reinforcement. Lack of reinforcement may lead to mould cracking and failure (see Chapter 7: Handbuilding).

Selection of material and method affect the amount of finishing work to be done after firing. It is possible to reduce the risk of mould and glass sticking to each other, through careful choice

and application of materials as well as temperature and time control during firing. This maximises the potential for achieving a high-quality surface straight out of the mould. If you do not want to cold-work a surface, then this should be factored in to decisions about the mould-mix materials, method of making, recipe and type of glass you use (see Chapter 3: Understanding Ingredients, Chapter 6: Mould-making Methods, Chapter 10: List of Mould-mix Recipes, and Chapter 13: Surfaces and Finishes).

Research projects

Although plaster-based mould-mix recipes are the most popular due to their relatively low cost, ease of mixing and application and the ease with which ingredients can be sourced, there are also a number of other significant approaches.

The ceramic shell process, which is often used for metal casting, was explored for glass casting by Aron McCartney at Central St Martins during a Ph.D. study (See www.csm.arts.uk).

The research project I took part in at the Royal College of Art (RCA) between 1999 and 2001 examined contemporary practice in refractory mould-making across a wide range of practitioners in kiln-formed glass. The findings of the research project clearly identified the primary impetus for experimentation with both mix and method as aesthetic, as opposed to technical, in both contemporary and historic contexts.

Although there is not a great deal of technical data available regarding practitioners from previous centuries, some information has survived.

During the project at the RCA, we tested a recipe attributed to French 19th-century pâte de verre practitioner Gabriel Argy-Rousseau (1885–1953). Another research project carried out by Max Stewart at the University of Wolverhampton, and led by Professor Keith Cummings, focused on the work of French artist Amalric Walter (1870–1959). Both these projects replicated the historical mould-mix recipe as accurately as possible using contemporary materials (see Further Reading p.134, Chapter 3: Understanding Ingredients and Chapter 10: List of Mould-mix Recipes).

GAYLE MATTHIAS

The *Generation* pieces were made for the exhibition Casting and Installing at the National Glass Centre in 1999 as part of a series. They were also produced as a case study for Aron McCartney's Ph.D. into ceramic shell processes. This allowed the moulds to be thin to allow heat transfer to the glass, permitting a thin-walled glass cast. Wax models were dipped in coloidal silica mixed with molochite in suspension followed by a stucco of coarser molochite. This process was repeated at least four times.

Generation by Gayle Matthias, 1999. Ceramic shell-method casting, ht: (tallest) 30cm (approx. 12in). Photo by Andra Nelki.

UNDERSTANDING INGREDIENTS

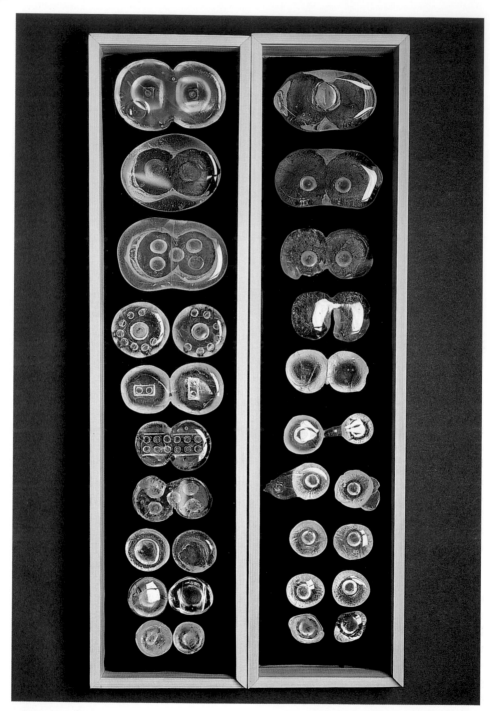

20 20 by Angela Thwaites, 2000. Cast lead crystal, 35 x 9cm (13¾ x 3½in). Two boxes containing individual glass pieces, each piece made directly from clay models using simple 50:50 quartz/plaster mould mix. Photo by Robert Taylor.

CHAPTER THREE

UNDERSTANDING INGREDIENTS

Before undertaking any mould-making, understanding the properties of the constituent ingredients involved in a mould mix is vital. There are many possible ingredients, so I have made a selection which are readily available and in common use (see Further reading and Suppliers).

Binders, refractories and modifiers

Building on a concept suggested by James Kervin and Dan Fenton in their book *Pâte de Verre and Kiln Casting of Glass* (1997), a mould mix can be analysed as having three major constituents: binders, refractories and modifiers. Each of these has particular functions, and can be combined with the others in different proportions, using a range of readily available materials, to create refractory moulds.

The **binder** takes and retains the shape from the original model and holds the other constituents of the mould body together. This book focuses on the use of plaster as the binder, which is the most common amongst kiln-formed-glass practitioners, and is also relatively cheap and readily available. The plaster binder usually constitutes between 25 and 75% of the dry material in a mould-mix recipe (see Chapter 10: Developing

Your Own Recipes and Methods, and also Suppliers).

The **refractory** is the constituent of a mould mix which most resists the action of heat. Many practitioners use fine silica (200–300 mesh) as their main refractory ingredient. Quartz and flint are the main sources of fine-silica refractory in use in the UK.

Modifiers are usually added in relatively small amounts for particular reasons, and may change the overall behaviour of a mix. They can be used to adjust the setting time, give more surface detail or reduce the likelihood of mould mix sticking to the glass. An example of a modifier is ludo (see this chapter, p.29 and Chapter 14: Recycling).

Particle packing

To achieve dense and strong mould mix, it is necessary to consider how potential ingredients work together. One aspect of this concerns 'packing', which refers to the density of a range of different-sized particles distributed within a mould-mix body. Good packing results in an optimum mould density and strength:

'In adding refractories to a plaster-based mould formulation it is important to add material or materials that provide a range of particle sizes. This allows you to more closely pack the refractory

particles in the investment mix so that they form a stronger and denser matrix. Then when the plaster starts to shrink at about 1200°F [650°C], it can grab tightly onto this stable matrix, resulting in increased mould strength and decreased shrinkage.' (See Further reading, *Pâte de Verre and Kiln Casting of Glass*, Kervin and Fenton).

The best particle size combination involves:

40% large
30% medium
30% small

where medium is a quarter of the diameter of large, and small is a quarter of the size of medium. Basically, these sizes fit together closely with the least space in between, and this provides the density necessary to develop strength. Interestingly, the most commonly used formula for mould mix is usually a half-and-half plaster and silica recipe. As a direct result of the information about packing, the research project at the RCA experimented extensively with mould mixes using one third binder, one third 'new' refractory and one third modifier.

'This formula, and particularly the use of ludo as the modifier, allowed us to introduce a greater range of particle sizes into the mix, resulting in better packing, and therefore stronger moulds.'
(*Mixing with the Best*, Angela Thwaites, 2001.)

To achieve good particle distribution, and therefore good packing, all mould mix ingredients need to be mixed together dry, before being added to water (see also Chapter 10: List of Mould-mix Recipes, and Chapter 6: Mould-making Methods).

Binders

Plasters

Plaster is made from calcined gypsum (calcium sulphate dihydrate $CaSO_4.2H_2O$), which is a naturally occurring mineral. In order to create plaster, the gypsum is processed by heat, humidity and pressure to form calcium sulphate hemihydrate $CaSO_4.\frac{1}{2}H_2O$.

A chemical reaction takes place when plaster is added to water and it rehydrates, thickens or 'goes off', and then sets into a dense, solid mass. The amount of plaster to water must be proportionally correct in order for the plaster to develop its full strength and density, and it must be thoroughly mixed (see Chapter 6: Mould-making Methods, and Further Reading, *Industrial Ceramics*, F. and S.S. Singer).

There are two main types of plaster: the **beta plasters** are a range of medium to soft plasters; these are cheaper and more widely available than **alpha plasters**, which have been prepared from gypsum at higher temperatures. The setting time varies quite considerably among the different types and products available – from 15 to 30 minutes.

The most commonly used types of plaster in the UK are:
Pottery plaster
Casting plaster
Fine casting plaster
Dental plaster
High-density (Keramicast) plaster

Dental and high-density plaster are the alpha type, and are more expensive than the others listed. I find that the slow setting of Keramicast (up to 30 minutes) is good for handbuilding large

moulds, and its hardness an advantage for handling during steaming, drying and kiln packing (see Chapter 7: Handbuilding, Chapter 9: Mould-drying, Kiln-packing and Firing, and Suppliers).

In a kiln firing plasters begin to lose their strength and break down at temperatures as low as 50°C (122°F), and lose significant structural stability in the range 700–840°C (1292–1544°F). A mould made only of plaster will crack apart completely in a kiln firing. This shows the necessity for refractory ingredients in mould mixes.

Refractories

Refractories usually make up between 50 and 75% of an investment-type mould mix for casting glass. They are resistant to change at casting temperatures in a working range which is usually between 780 and 950°C (1436–1742°F).

The refractory gives stability to the investment mould after the plaster binder has lost all significant strength. Some refractories can also act as modifiers. (See *Particle packing* above and Kervin and Fenton, p. 96).

Common types of refractory are:
Alumina
Fine silica (200–300 mesh) in the form of quartz, flint and cristobalite
Grog – fired, crushed clay
HTI – crushed high-temperature insulation brick
Ludo – fired, crushed refractory mould material
Molochite – calcined kaolin (china clay)
Sand in the form of silica and olivine

Alumina (Al_2O_3)

Alumina is a high-temperature refractory that does not melt until 2050°C (3722°F), which is far above glass-casting temperatures. It is used raw in the form of emery and corundum as an abrasive, and calcined and ground to produce refractory products. It can be found commercially in various grades.

Alumina is not reactive to glass, and so is theoretically good for moulds containing glass types requiring higher temperatures for casting. It is also used as a component in bat wash or shelf primer (see Glossary). It contains a range of particle sizes, to improve mould density and strength (see *Particle packing*, p.25).

Fine silica

'There are three crystalline forms of silica, namely quartz, tridymite and cristobalite.'
(See Singer and Singer, p.168.)

Silica is the most plentiful element on Earth after oxygen. It is also one of the constituents of glass itself. The melting temperature of silica is 1710°C (3110°F), lower than alumina. As a mould-mix ingredient it is therefore more likely to become reactive with glass at casting temperatures, and transfer of fluxes may occur between the glass and the boundary layer of the mould, resulting in the two sticking together. This is alleviated by drying and pre-firing moulds before casting glass into them (See Chapter 9: Mould-drying, Kiln-packing and Firing)

Quartz (SiO_2) is the most stable form of silica, and there are two forms of quartz. Alpha quartz is stable to 573°C (1068°F), Beta quartz from 573–870°C

UNDERSTANDING INGREDIENTS

(1068–1598°F). Crushed, pulverised quartz, or silica flour as it is also called, is by far the most widely used refractory in a basic 50:50 mould-mix recipe with a plaster binder. When finely ground into flour form, silica dust presents serious health and safety concerns, especially in a particle size of 2–8 microns (contained in 200–300 mesh size). It is therefore important to avoid inhalation by handling it with care, and using extraction and wearing a respirator when mixing (see Chapter 6: Mould-making Methods).

During a kiln firing, as the temperature reaches 573°C (1066°F), the crystals in quartz rearrange themselves, changing from alpha to beta quartz.

This change is called quartz inversion and is marked by a slight increase in volume (approximately 2% expansion); it's a reversible process, so during cooling the quartz contracts again and reverts to its alpha state. This expansion and contraction can cause mould cracking, so it is advisable to add other materials to a mould-mix recipe to reduce the impact of the quartz inversion (see *Particle packing* above).

Flint is similar to quartz, and is also often used in mould mixes for glass. Like quartz, its fine particle size (200–300 mesh containing 2–8 micron size particles) poses a health concern, so it is often packed and supplied damp to minimise hazardous dust contamination.

Flint may indeed be worse than other forms of fine silica, due not only to the particle size but also to the sharp, spiky nature of these particles, which results from the crushing process involved in its manufacture. Flint contains a small amount of calcium, which causes it to

convert easily and quickly to cristobalite at casting temperatures. It does not lend itself to dry mixing when supplied damp, and so is usually added directly to water before plaster when used in mould-making. It does not have any apparent advantage over other forms of fine silica.

Cristobalite is one of the three types of silica, all of which have the same formula as SiO_2 but differ in the way their atoms are bonded together in lattice structures. Some practitioners use this as a face coat with a fine, hard plaster such as dental plaster. Quartz converts to cristobalite at high temperatures. Depending on particle size, it can be more reactive at casting temperatures (a working range of 780–950°C/1436–1742°F) than quartz, so it may have a tendency to stick to glass unless combined with other materials in a mould mix. Its fine particle size rates it as a hazardous dust, possibly even more so than quartz or flint. Cristobalite contracts suddenly at 226°C (439°F) during cooling, which can result in cracking in a mould mix or clay body. To reduce the likelihood of this happening I suggest limiting cristobalite to 10% and mixing it with other refractory ingredients, as well as firing slowly to 573°C (1063°F) going up and 226°C (439°F) coming down.

Grog

Grog is ground pre-fired clay or ceramic material. It is a refractory filler with low thermal expansion. It is readily available in a variety of mesh sizes from ceramic suppliers. In a mould mix it acts to give better molecular packing, reduce shrinkage and provide thermal shock resistance (see *Particle packing* above).

It also increases permeability and helps the mould body to dry uniformly, avoiding warping or stress-cracking before and during firing. It may, however, stick to the glass, depending on the firing temperature, time and type of glass used. Generally, fine grog should be used and the moulds pre-fired. Coarse particles of grog may stick to some particularly soft types of glass with a very high lead content and low melting temperature.

Grog can also be used in small quantities in a mix as a modifier, or added to outer layers of a handbuilt mould (see Chapter 7: Handbuilding).

High-temperature Insulation (HTI) brick

Crushed high-temperature insulation brick is a highly refractory material which also acts as a modifier. Made for building kilns and furnaces, old bricks can be crushed mechanically or by hand, and used in a mould mix. Crushing this material gives a variation in particle size which results in better packing, making the mould stronger and also reducing shrinkage (see *Particle packing*, p.25).

Small chunks of this refractory can be added directly into a mould mix at the pouring stage to act as an aggregate to inhibit the development of cracking through the mould body.

Ludo

(See also p.91 and p.105.)

Ludo is pre-fired refractory mould mix, which has lost both chemically and physically bound water during firing. The resulting dry, crumbly material can act as both a refractory and a modifier, and can be added to a new mould mix either crushed to a powder or in chunks. Using ludo is good practice in terms of both economics and sustainability. It can be used in quantities up to 50% of the total dry material content of a mould mix, thus saving on the cost and use of new materials.

The addition of ludo to a mould mix in crushed form gives increased variety in particle size, which contributes to better packing, resulting in improved mould strength and reduced shrinkage (see *Particle packing* above).

Chunks of ludo can be added directly at the time of setting up the model, or as a mould mix is being poured, to stop cracks running through the mould body. Ludo is also easier to remove after firing as it sticks less to the fired glass surface because all its ingredients have been pre-fired. As it will always have new material added to it as part of a mould mix, ludo can be used over and over again.

Ludo will change the mixing and setting time of the 'new' plaster in a mould mix as it contains pre-fired plaster (see p.31, *Setting-time modifiers*).

Molochite

Molochite is a fine white clay (china clay) with a high alumina content. It is available from ceramic suppliers in various mesh sizes and has both refractory and modifier qualities. Molochite can be used as an ingredient in a mould mix recipe as up to 20% of the dry weight of material. It shrinks less than kaolin (china clay) as it has been calcined, so contributes to mould strength and to a good-quality cast-glass surface, as mould mixes containing it separate from the glass easily after firing, (for an example see Gayle Matthias, p.23).

Olivine sand

Olivine is a greenish sand made from olivine rock $(Mg,Fe)_2SiO_2$, a naturally occurring mineral comprising approximately 85% magnesium silicate and 10% iron silicate and traces of oxygen, silica, manganese and nickel. (see Singer and Singer, pp.422/3).

As part of the research project, we brainstormed, sourced and tested this material after searching for alternative refractories. Olivine sand is highly refractory and has several advantages for use in mould mix.

Olivine offers a potentially safer alternative to quartz due to its low silica content and the coarseness of its particle size. This makes for an attractive option in terms of reducing hazardous dusts in refractory investment mould-making.

Olivine sand makes a dense and heavy mould which is resistant to cracking and thermal shock when used in quantities of 25–50% of the dry material content of a mould mix. It has low thermal expansion and a softening temperature of about 1700°C (3092°F), and thus a low potential level of reactivity to glass at casting temperatures, though some of the coarser grains may become embedded in the surface of soft glass. I would recommend pre-firing moulds before use (see Chapter 9: Mould-drying, Kiln-packing and Firing) and using olivine in combination with a face coat of fine materials, where it provides a high level of resistance to cracking and thermal shock.

The product labelled '120 olivine', which we used for the research project, is actually a mix of 50–180 mesh size particles. This variation in size adds strength as part of a molecular packing system of interlocking particles.

Silica sand

This is a somewhat misleading name, as most sands have a silica content. However, silica sand is available from ceramic suppliers and has refractory potential. Naturally, it has a very high silica content, which gives it the potential to become reactive to glass at high casting temperatures. It has larger particle sizes than, for example, quartz, so it is also a potentially lower-level dust hazard. It also has a varying particle size, and so can be used to improve particle packing in a mould mix.

Silicon carbide

This highly refractory material theoretically presents a potentially interesting mould-mix component. It may be a more economically viable alternative if carefully reclaimed and recycled after use as an abrasive from cold-working glass (see Chapter 14: Recycling).

Material modifiers

Kaolin (china clay)

Kaolin is a fine, white-firing clay with low plasticity and a high refractory quality.

It is a useful modifier and can be added to a mould-mix recipe in percentages of up to 10%. The addition of 5% kaolin to the mould-mix recipe gives a good cast-glass surface, and the mix releases very easily after firing.

English china clay contains 38–39% alumina, which, along with its plate-like nature and fine particle size, contributes to its ability to release from fired glass and also improves replication of the fine surface detail of a glass casting. Kaolin may also act as a binding agent

in a mix, and contribute to keeping the other mould-mix components in suspension when mixed with water. This would prevent refractory and plaster components from coming into widespread contact with the glass, and, coupled with kaolin's fine particle size, would help to prevent mould mix sticking to the glass.

In quantities larger than 10%, kaolin may contribute to devitrification of the glass surface. Kaolin and talc are very absorbent and must be dry-mixed with other ingredients before being added to water, to prevent lumps.

Talc

Talc consists largely of magnesium silicate, and some forms (mainly those mined in China) contain asbestos, so check with your supplier before ordering it. Talc has refractory properties and is used in the production of kiln furniture. It is inert up to 850°C (1562°F) and has high expansivity, then shrinks upon cooling. Fired to a high temperature it becomes cordierite, which then has good resistance to thermal shock.

Talc was documented in some 19th-century French mould-mix recipes, and is still used by some practitioners. It has a fine, plate-like quality, similar to kaolin, which can help in the reproduction of detail.

Vermiculite/perlite

These are heat-expanded, lightweight, low-expansion clay products which are available in several mesh sizes and are used as insulation materials. They are relatively cheap and available through builder's merchants in the UK.

Vermiculite and perlite can be used as refractory fillers in mould-mix recipes. They are relatively inert at casting temperatures, and contribute to reduced shrinkage, thermal-shock resistance and weight-saving. They have a tendency to stick to glass, so are best used in conjunction with a face coat (see Chapter 7: Handbuilding).

Foaming agents/detergents/liquid soap

These can be introduced into a mould mix during the wet-mixing stage, to create a matrix of tiny bubbles which give lightness and porosity to the mould. The use of foaming agents can also contribute to reduced mould shrinkage, the inhibition of cracking at a micro level and easier shedding of physically and chemically bound water.

Setting-time modifiers

The mixing and setting time of mould mixes can be adjusted by the addition of different ingredients:

'... materials such as alkali sulphates or chlorides [e.g. salt] are added to accelerate set while ones such as borax, gelatin or starch are added to retard it and the addition of either will usually reduce setting expansion'.
(Kervin and Fenton, p.92)

The temperature of the water used to make a mould mix will also affect the setting time. Using warm water causes faster setting, while colder water slows down the setting process. Mixing with water at a temperature of 30°C (85°F) will noticeably speed up the setting time. This can be an advantage if you are using some of the alpha plasters, which

have long mixing and going-off times (see *Binders*, p.26).

Faster

Faster mixing and setting can be achieved by using ludo. Its previously set and fired plaster content acts as an accelerator to the new plaster in the mix. The addition of too much may, however, weaken the formation of gypsum crystals as the new plaster sets, which could compromise the mould strength, so a maximum of 50% ludo is recommended in any recipe.

Adding cooking salt (sodium chloride) will also speed up the setting time of the plaster, so mixing with salt or sea water can change your overall working speed considerably.

Slower

Setting time can be slowed down by the addition of acidic materials such as citric acid or vinegar, and I have also used strong coffee. Bear in mind when using liquid modifiers that adding even a medium amount may make it necessary to proportionally reduce the amount of water to avoid weakening the mould mix. In any case the percentage addition should be small, e.g. 1 tablespoon to 10 litres of water.

Fibres

The use of fibres in mould mixes for glass is more difficult to quantify accurately, and material scientists consulted as part of the research project were not completely agreed on the exact effects. However, the addition of various types of fibres to a mould mix can significantly change the porosity, affecting the strength of a mould during drying, model removal and handling, and also during firing.

Fibres share common characteristics and their use in ceramics is documented:

'The use of straw as a reinforcement in adobe bricks ... mixed in with the plastic clay when the brick is made, gives a greatly increased dry strength because of the tensile strength of the embedded fibres.'
(See Rhodes, p. 57.)

Fibreglass

The most commonly used modifier in the UK is chopped fibreglass strands, which are thought to increase the tensile strength of the mould body at drying and curing temperatures as described by Rhodes again in relation to clay bodies:

'The incorporation of fibreglass in clay bodies gives tensile strength which is lacking in clay alone, and complex forms which would ordinarily crack in drying can easily be made ... Dry strength is enormously increased.'
(Rhodes, p.59).

The testing carried out with typical soda glass fibre strands showed that they melted at the top end of the casting temperature range 850–950°C (1562–1742°F), which means that they give little or no structural strength to the mould at this point. It does seem, however, that the use of any kind of fibre promotes the shedding of water from moulds as they are dried and fired.

Subsequent to the completion of the research project, I have gone on to use fibreglass tape between layers of mould mix. It is easily available at builder's

merchants and DIY stores, as it is used in construction for covering the joins between sheets of plasterboard. I find it easy to use cut up into strips, and it has the advantage that the fibres are not loose and do not get stuck into your skin so easily while being handled (see Chapter 7: Handbuilding).

Organic/natural fibres

Fibres such as sawdust and shredded or pulped paper are thought to retain water during mould setting and curing. This allows good growth of gypsum crystals, which in turn results in improved mould strength.

During air-drying the fibres shed water through the process of wicking and later burn out altogether to form a matrix of small air holes throughout the mould body. This may inhibit cracking as the 'air space' is much less subject to expansion and contraction.

It is also possible that a carbon deposit could be left after firing that would assist by acting as separator between the mould surface and the glass. This last deserves further study and might be clarified through microscopic examination.

Manmade/non-organic fibres

Non-organic fibres such as polypropylene monofilament may function in a similar way through the effect of tiny channels that wick water from the interior of the mould body to its surface.

As part of the research project, we tested the product Fibrin 23, polypropylene monofilament fibres. A publication from the manufacturing company describes the effects of the fibres as improving resistance to spalling at high temperatures when used in concrete, which can be seen as similar to a mould body. Tests showed that using the fibres increased the permeability of a mould mix, which allowed water to be driven off more easily during firing. This in turn reduced the tendency for moulds to crack or spall during the firing process.

Refractory fibres

Ceramic fibres in the form of Kaowool or Fiberfrax, and refractory zirconia fibres, were also tested as part of the research. They were found to give structural support to a mould mix at high temperatures without becoming reactive to the glass. They help also to alleviate mould shrinkage by spanning tiny cracks that may develop. Like the other types of fibre described above, ceramic fibres may also contribute to the wicking effect by forming tiny channels through a mould body that facilitate the passage of water from the interior to the surface. Ceramic fibre is refractory and so provides thermal-shock resistance during firing as well.

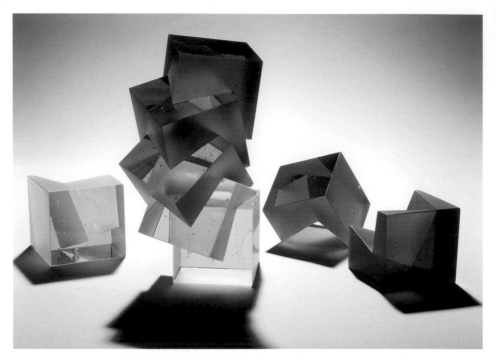

Themes and variations III, in incandescent light (above) and in fluorescent light (below) by Heike Brachlow, 2010. From the artist's Ph.D. study at the Royal College of Art, creating a subtle range of coloured glasses for casting. Photos courtesy of the artist.

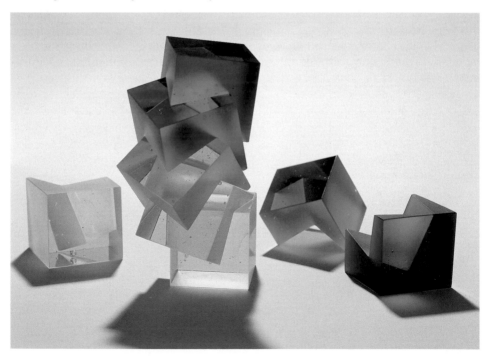

TYPES OF GLASS

The interaction between the surface of a mould and the glass melted into it is significant. To achieve the best possible results, mould-mix recipe and glass must be considered together, and the type of glass to be used carefully chosen.

The physics and chemistry of glass are complex topics and constitute an in-depth study in their own right. For studio glass, and kiln-forming in particular, it is necessary to have an understanding of the basics in order to be able to make creative choices. (For more detailed information about the material science of mould-making for glass, see Chapter 3: Understanding Ingredients, and Further Reading.)

Glass can be divided into a number of different types. Alongside this are many manufacturers and numerous products. Here is some basic information about glass, and some of its more commonly used types, to make it easier to understand and select the appropriate materials. A list of suppliers of glass and materials for kiln-forming is provided at the end of this book.

A brief look at the properties and constituents of glass

Glass is the fourth state of matter; liquid, solid and gas are the other three. Glass can be seen as a family of materials, like metals or clays, each member of which has related but distinct qualities and properties. These material properties need to be considered and at least the basics understood in order to work with glass successfully.

Silicon dioxide (SiO_2) is a naturally occurring substance, in the form of pure crystalline quartz and cristobalite as well as other silicate minerals. It can be referred to as a 'glass former', to describe its role as a primary component of glass.

Pure silicon dioxide glass is called 'fused silica' or 'fused quartz', but it has a softening point which is far too high for it to be worked 'by hand'. Adding other oxides to the silicon dioxide, for example soda (Na_2O) and lime (CaO) lowers the viscosity and the temperature needed for melting, and makes possible the forming of the resultant glass. Soda and lime also contribute positively to chemical and optical qualities in a glass.

There are a range of other primary glass formers as well as silicon. These include oxides, sulfides, tellurides and selenides of the elements boron, phosphorus, arsenic, vanadium, zirconium and germanium. Glass can also be formed using one of these primaries in combination with so-called intermediates – titanium, zinc, lead, aluminium and cadmium – whose oxides play a part in the formation of a glass. The addition of these oxides affects the properties of the glasses they help to create.

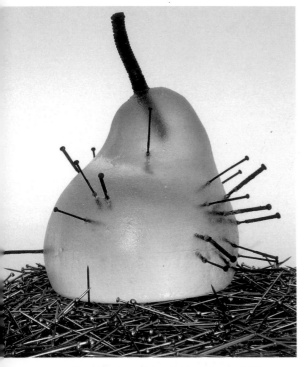

'Even Mother said…' by Tania Porter, 2009. Bullseye glass, cast from patties, with copper and steel inclusions; mould mix: plaster (50%) and flint (50%); firing temp. & soak time 860°C (1580°F) for about six hours. 10cm (4in) high x 9cm (3½in) diameter, including pins. Photo by Tania Porter.

Commonly used glass types and manufacturers

Glass types are very often described according to their oxide constituents. Soda lime, lead (or lead crystal), barium, lithium and borosilicate are amongst the most common.

Borosilicate glasses have good resistance to thermal shock, and are used to make items which need to endure localised heating such as scientific glassware. Some borosilicate glasses are soft enough to cast and cold-work.

Soda lime glasses are hard glasses, usually with a low flow factor, requiring higher temperatures to melt (e.g. 860–950°C/1580–1742°F) and longer time to refine and polish through cold-working processes. Bottles and windows are usually made with soda lime-type glass.

Pilkington Brothers developed what is called the 'float' glass method of making large-scale pieces of sheet glass for windows and architecture in the 1950s. Bottle, window and float glasses can be melted successfully into open moulds or simple shapes at fairly high temperatures, but are not well suited to casting from a reservoir. They are stiff, with high viscosity, so do not flow easily and have a tendency to devitrify.

Several manufacturers, such as Bullseye, Uroboros and Spectrum based in the USA, and Banas in the Czech Republic, have developed special glasses

LEFT: Red glass manufactured in China, sourced via a Czech supplier. Photo by Keiko Mukaide.

ABOVE AND RIGHT: Details of *Orphica* by Tracy Nicholls, made using Gaffer casting crystal. The piece won the British Glass Biennale prize in 2008. Photos by Ester Segarra.

BELOW: *Mala Strana*, cast by Angela Thwaites in Libenský's studio, 1984. Czech 40% lead-crystal glass, showing a broad tonal range of colour. (See also p.12.) Photo by Angela Thwaites.

for kiln-forming purposes. Although chemically cousins to bottle/window glass, these glasses have been specially produced to be softer and to melt much more easily, and are available in a wide range of compatible colours and forms for studio use.

Glass which is **lead**-based is soft, and therefore melts at much lower temperatures (e.g. 780–830°C/1436–1526°F) than soda-lime glass. It is also much softer to grind and polish, though it scratches more easily and can be prone to chipping. To be described as 'full lead crystal', glass has to have a minimum content of 24% lead oxide. The New Zealand manufacturer Gaffer produces a glass with 40% lead-oxide content, developed especially for kiln-casting.

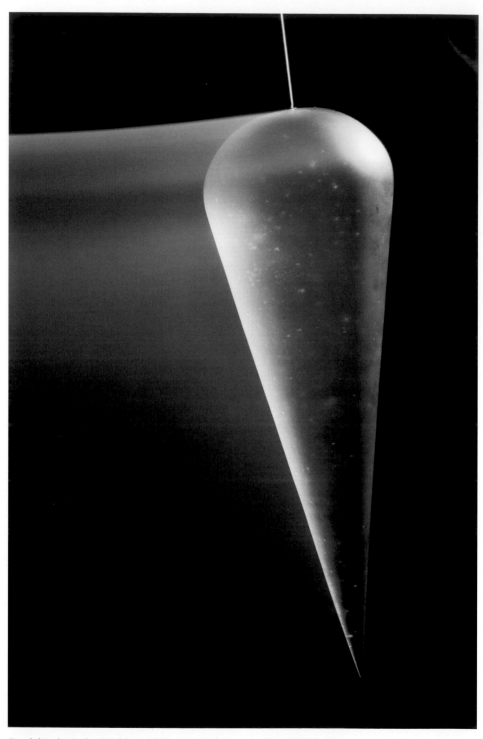

Pendulum by Heike Brachlow, 2010. Lost wax cast, ht: 17cm (6¾in). Photo courtesy of the artist.

MODEL AND MASTER MOULD-MAKING

Models

In all cases it is important to reiterate that the model is the **positive** – i.e., this is what you want to make in glass – and the mould is the **negative**, which helps reproduce the positive.

The acronym 'wysiwyg' (what you see is what you get) is a useful aide memoire – the model is 'what you see' and becomes 'what you get' in glass. (see also Chapter 1: Kiln-casting Glass).

Below is an outline description of a selection of model-making materials in common use. (For in-depth information on these and other potential model-making materials and techniques, see Further reading and Suppliers.)

There are many materials for model-making where the refractory mould is made directly over or around the model. For making repeats of the same shape or form it is usually necessary to make a master model and/or master mould. This is briefly described later.

A number of different materials may be used to make a model from which you can produce a casting. These include clay, wax, plaster, rubber, alginate, wood, plastic and polystyrene. Which material you choose will depend on various factors, from personal taste about feel and texture, through to questions of scale, time and material properties (see descriptions of materials on the following pages); and the surface quality, texture and detail required in the resulting cast glass.

A number of contemporary practitioners are using rapid prototyped models (e.g. Heike Brachlow and Shelley Doolan in the UK). It is also possible to work directly from natural forms, as Joe Harrington does, who uses ice as his model (see also Chapter Seven: Handbuilding, p.73).

How you separate and remove the model from the refractory mould is another important consideration. Regardless of which material you use, it is essential to carefully remove the model so as not to damage the surface, details, undercuts and edges of the refractory mould.

If any 'crumbs' of mould mix fall into the mould, these can be easily picked up on the moistened tip of a fine paintbrush, or, if there is good access, with a pair of tweezers. Any pieces of material left inside the mould cavity are a potential contaminant and must be removed before the mould is fired and before any glass is placed in either the mould or the reservoir. Fragments of clay, plaster or any mineral-based material will float around in the molten glass and remain in the casting after firing (see Chapter 9: Mould-drying, Kiln-packing and Firing, and Chapter 14: Recycling).

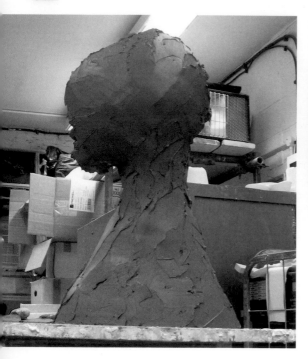

Starting point for clay model for *Penelope and Odysseus*, 2007. Ht: approx. 50cm (20in). Photo by Angela Thwaites.

Finished clay model for *Penelope and Odysseus*, 2007. Ht: approx. 50cm (20in). Photo by Angela Thwaites.

Clay

Clay is a versatile, inexpensive and reusable model-making material, which is easily available to most makers and can be worked in a number of ways. Modelling can be additive, by building up and/or gradually adding new pieces of clay; or reductive, by starting with a rough shape or lump and gradually removing and refining the form, or by carving when the clay has reached its leatherhard state. All three of these methods can be used in combination (see Suppliers and Glossary).

It is often helpful to use red earthenware clay for model-making, as the colour of it contrasts with the whitish plaster mould mix and it is easy to see when all clay is removed and the surface of the mould is clean. It is also possible to use a 'piece' or 'part' mould method to facilitate clean and complete removal of a clay model (see Chapter 7: Handbuilding).

Clay needs to be removed from the refractory mould soon after the plaster mixture has set, and while the clay is still soft. Clay can be removed in strips using a loop tool, starting in the centre back of the exposed model. Care needs to be taken not to dig into or damage the mould surface during clay removal, particularly around undercuts and details. Once most of the bulk of the clay has been removed, the rest can be peeled out cleanly and the surface gently dabbed and sponged to remove any residue. Avoid excessive cleaning or rubbing as this can erode and damage the surface quality and details of the mould.

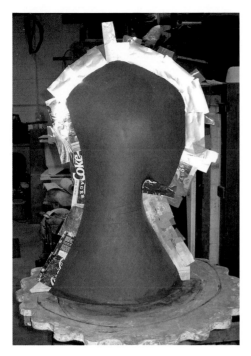 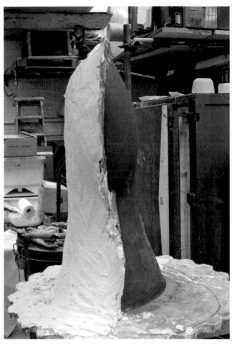

Model with thin metal shims pushed gently into the clay to create a division into two sections.

The first half of the plaster master mould has been created by applying Keramicast plaster by hand, by flicking and then pasting. Notches or keys are then cut into the edges of the plaster mould, and soft soap used to seal the surface where the second part of the mould will touch the first, so that the two parts can be easily separated.

The sequence of images (see above) shows the production of a two-part plaster master mould taken from a clay model to make *Odysseus*. I used the master mould to create two wax models and then carved, refined and subtly changed the shape of the second to produce *Penelope*.

It is also possible to make a refractory mould in parts using the same steps as shown in this sequence, but applying mould mix instead of just plaster (see also Chapter 7: Handbuilding and Chapter 10: List of Mould-mix Recipes).

Wax and lost wax

Wax is a popular option for making models for casting glass, and the way it is used is often called *cire perdue*, which translates as 'lost wax'. This refers

to the removal of the wax from the refractory mould, leaving a clean cavity for casting into. Most glassmakers steam wax out so it can be recycled and reused – so that it is not in fact 'lost' (see Chapter 14: Recycling). Wax can be melted out of moulds in a kiln, but this can be a messy process, costs more in electricity and if allowed to burn contaminate the inside of the kiln. Any wax remaining in the mould can also burn, resulting in ugly black carbon trapped in the glass after firing.

Like clay, wax is a potentially sensitive medium, and is relatively easy to use once you have learned to handle it.

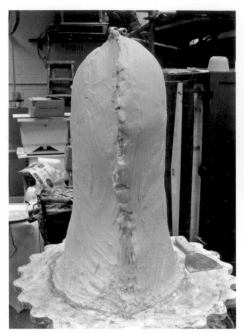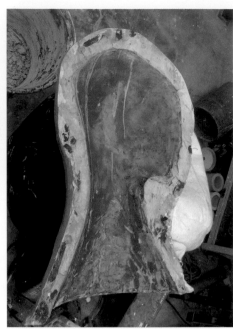

ABOVE: Both halves have been made, and the use of pink food colouring in the plaster mix for the second part clearly shows up the seam between the two halves. I removed most of the clay from inside to make it easier to separate the two parts of the mould.

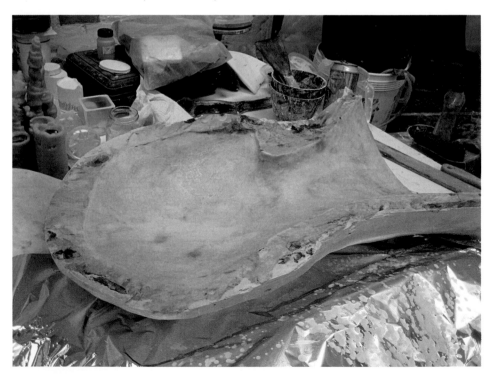

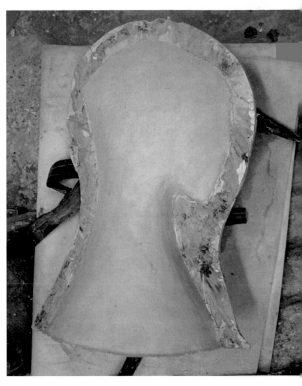

BELOW LEFT: Very hot wax is brushed onto the inside of the plaster mould. As the wax cools and thickens, it is scumbled into the mould up to a thickness of 6mm (¼in). Once wax has been built up on both halves separately, the edges are trimmed and the mould is put back together. Then warm (but not hot) molten wax is poured and swilled inside to join the two halves together. The outside surface is then worked to give a fine cross-hatched texture, and to blend in the seam. Photo by Angela Thwaites.

RIGHT: Completed wax model for *Odysseus*. Photo by Angela Thwaites.

BELOW: The two halves are separated and the clay removed. All the clay is cleaned off the surface before the wax model is made.

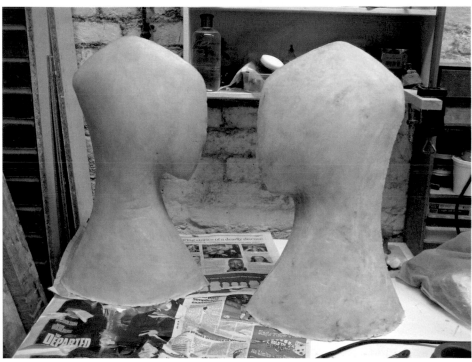

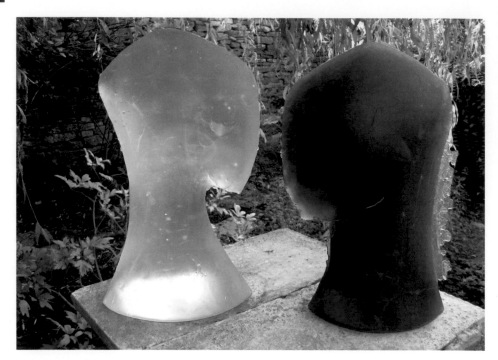

Penelope and Odysseus, cast by Angela Thwaites, 2007. Czech 'Banas' casting glass, ht: approx. 50cm (20in). Photo by Angela Thwaites.

In combination with a well-made refractory mould of fine materials, wax can reproduce details as fine as a fingerprint (see Chapter 10: List of Mould-mix Recipes).

Above are the finished works, *Penelope and Odysseus*, made from the two-part plaster mould as shown on pp.41–3.

There are many types of wax: these include softer modelling waxes, which can be easily shaped by hand, and harder waxes, which are made for pouring into a master mould and can be carved and smoothed. Harder waxes can even be filed and worked on with surform tools and are good for making lightweight, hollow and large-scale models that are rigid enough to keep their shape during mould-making.

After making a wax model, it is often advisable to smooth and clean the surface before investing it. For smoothing I use a small amount of turpentine or white spirit on a flock-free cloth or paper towel to gently polish the surface of the wax mould. Another tip from Liz Waugh is to use neat methylated spirit (meths), which she says is a technique borrowed from bronze-casting, or you can use a degreasing solution made of washing-up liquid diluted with water, as if for washing-up but using cold water and with 'a few glugs' of meths added. With either of these methods, wait until the next day to make the mould, or until all the moisture has evaporated, or it will spoil the mould surface. Hairspray can also be used on the model to help break the surface tension of the water (which is held in the mould mix) as the mix spreads onto the model, enabling it to

get a better coating. Spray the hairspray evenly onto the wax model so as not to get any pools or drips, and allow to dry before mould making.

The main method of removal from the refractory mould is steaming, so that the wax can be saved and recycled again and again. So if you are buying wax for this process, find out first if it has a low enough melting point. Some of the waxes made for metal-casting and jewellery purposes are not suitable as they are too hard to be steamed out (see Suppliers).

The materials used for refractory moulds must therefore be durable enough to withstand steaming. If the model is large and complex, it may need to be steamed over a long period of time to remove all the wax, so it is advisable to use an easily melted wax, e.g. Tirranti's green wax, combined with a harder plaster as part of the mould-mix recipe (see Suppliers, Chapter 8: Core Casting, and Chapter 10: List of Mould-mix Recipes). This helps minimise steam erosion and protects the surface and the details in the mould. If the mould is subject to excessive steaming, it can become weakened through being waterlogged. Regular supervision is therefore required throughout the steaming process to prevent this happening and to ensure complete removal of all wax. Covering the mould in a plastic bag or upturned plastic bucket can speed up the steaming process.

Rubber

Flexible rubber models can be used, and these can have several advantages. One is the creation of a relatively durable model which can be used again and again with minimal wear or loss of

Detail of *Odysseus* showing fine surface markings reproduced from the wax model. Photo by Angela Thwaites.

quality in reproduction. Another is ease of removal – a soft, flexible rubber model can be peeled carefully from a mould with minimal risk of damage. Although the initial making of the rubber model may take longer than other materials and methods, time can be saved which would have been spent steaming out wax or cleaning out clay. This can be particularly important if you are casting repeats of the same piece.

There are many types of rubber, including recyclable hot-melted gelflex and cold-cured silicones. In some cases a release agent may be needed to ensure clean separation of model from mould and good reproduction of surface quality. It may be necessary to run tests to find out if the release agent has an impact on the surface quality of the cast

Silicone model and casting mould by Heike Brachlow. Photo by the artist.

Cone wax model in master mould by Heike Brachlow. Photo by the artist.

glass (see Suppliers). Gelflex rubber is melted at about 150°C (302°F), so it is not suitable for use against materials or surfaces that will melt or be damaged by intense heat – for example, polystyrene and foam rubbers, some plastics and some painted surfaces.

Cold-cure rubber and gelflex are also very good materials for making master moulds as well as models (see p.46.)

Alginate

This is a useful material from the dental trade and can be used for model- and mould-making. It can give fine and sensitive details and is often used for taking impressions of skin texture, organic objects and other delicate surfaces. There are several types with various setting times, though they are all fairly fast-acting. It is necessary to follow carefully the manufacturer's instructions on quantities and mixing, and you may need several attempts before a quality impression or model is achieved. Once you have something you are happy to work from, you will need to go quickly to the next stage of the process, as the alginate form will shrink and dry out quickly and become very fragile. Wrapping it carefully in a damp

but not wet cloth, and then in a plastic bag and keeping it in the fridge, is one way of prolonging its useful life. Making a plaster positive from an alginate gives a good lasting model, and the possibility to correct, add or remove details or blemishes (see also Chapter 8: Core Casting).

Master model- and mould-making

Master models and moulds are produced to make repeats of the same shape or piece. It is often advisable to make a master model and/or mould even if you are only planning to make a one-off, so that if the casting is not perfect you do not have to start from scratch to remake it.

If you are starting the casting process with a fragile original from which you want to make repeats, it is particularly useful to create a master model and/ or mould in a sensitive material such as silicone rubber to preserve delicate detail, as well as reproduce form and surface (see Chapter 8: Core Casting, pp.82–5 for images of Max Jacquard's work).

The following sequence of images shows the steps for making a small

gelflex master mould from a clay model. Images (b) and (c) show the pour lines which occur if the gelflex is too cold or is not poured in one go. Image (d) shows a better result.

A master mould can also be used to generate a series of related pieces based on one form, but developed or transformed from an original. Wax is a key material for this, as it is straightforward to use in terms of additive or reductive processes – for example, cutting, collaging, constructing, distorting and texturing.

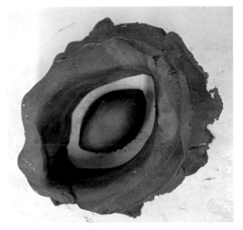

(a) Clay model and surrounding wall.

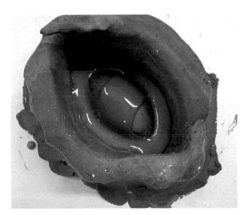

(b) Pouring melted gelflex onto the clay model.

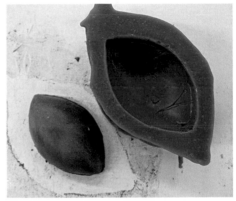

(c) Set gelflex showing pour lines.

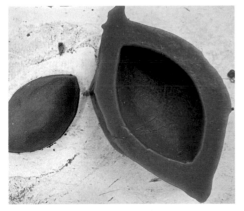

(d) Set gelflex showing a better surface than (b).

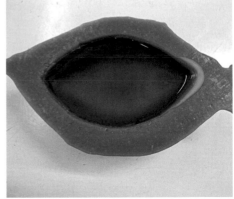

(e) Melted microcrystalline wax poured into the gelflex mould (d), showing white edge where it is starting to cool.

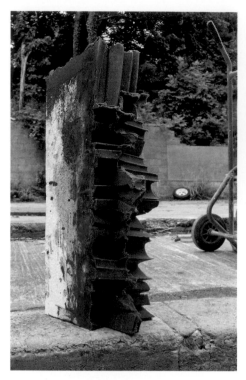

Microcrystalline wax and polystyrene model.

Microcrystalline wax and polystyrene model.
Photos by Colin Reid.

Steaming wax out of mould. Photo by Colin Reid.

Plaster, wood, polystyrene and inflexible models

Models made of a range of inflexible materials can also be used for refractory mould-making where there is a shape that will drop out easily, with no undercuts. In any case, shape and detail will need to be simple to ease removal and minimise potential mould damage. Many inflexible materials will need a release agent or separator, and may need to be sealed if they are porous. For plaster, soft soap or petroleum jelly (Vaseline) are usually used, and for wood the surface can be easily sealed by painting it with gloss paint, varnish or shellac.

Polystyrene is a useful model-making option, as it is soft and lightweight, and

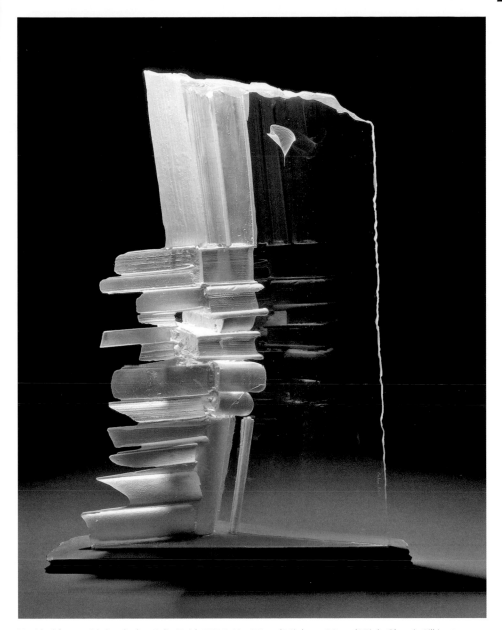

Untitled form with books by Colin Reid, 2008. Ht: 66cm (26in), w: 38cm (15in). Glass is Pilkington Special Glass optical. Photo by Colin Reid.

basic forms can be reused many times. A polystyrene model can be made in sections to ease removal, or carefully eased out of the mould, leaving a clean mould cavity ready for casting. Burning out or chemical dissolution are possible but are not recommended for environmental and health and safety reasons. Polystyrene can also be used in combination with wax.

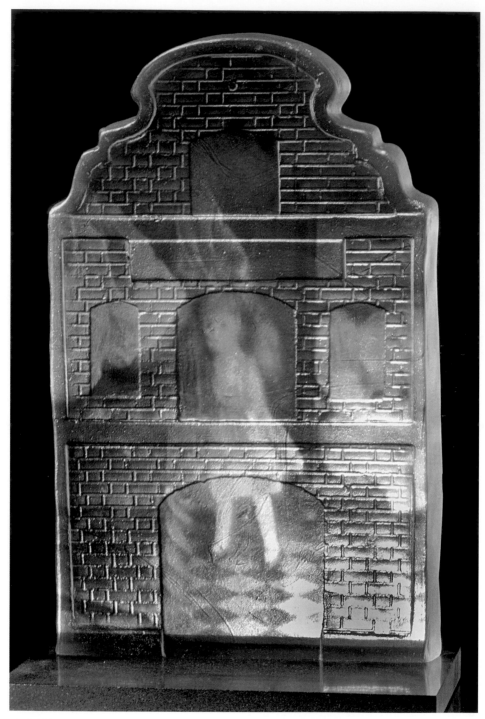

Fairfield I by Liz Waugh McManus. Glass and animation/film projection, ht: 40cm (15¾in), w: 23cm (9in), d: 3cm (1¼in). Photo by Simon Bruntnell.

MOULD-MAKING METHODS

Rigorous documentation is vital to developing an understanding of all processes – what does not work is as important as what does, so make sure you write everything down as you work. I use metric measurements throughout.

Things to think about before you start

Mix and method go together, and there are many possible combinations of the two, each affecting the other. In every case, mould mix must be chosen in relation to the shape, scale and surface of the piece to be made, the weight and type of glass to be used, and the temperature and length of firing needed.

Complex and/or larger-scale moulds may need reinforcing inside the mould mixture. Reinforcement needs to be considered and prepared in advance (see Chapter 7: Handbuilding – *Reinforcement*)

A key point to consider is that what is face up during mould-making will be face down inside the mould during casting, and that glass, like water, finds the easiest course and runs downhill not up! Venting may also be necessary to prevent air being trapped in the mould or in the glass during firing (see p.57, *Venting*).

Before starting to set up your model or make your mould mixture, consider, and make careful notes on, the following:

- Model – size, shape, material, surface quality and texture, method of removal from refractory mould
- Surface – quality and texture required, amount of potential cold working
- Glass – weight, type, amount needed
- Firing – temperature and duration
- Mould – materials and recipe, size and handling before and after firing

Now you have your model and the necessary information about it, you can start to make decisions. Firstly, decide which type of glass to use (see Chapter 4: Types of Glass), then measure the amount of glass you are going to need to make your object.

Water displacement

There are several ways to find out how much glass you are going to need to fill a particular mould. Here are three straightforward water-displacement methods which, if carried out carefully, will give a very accurate measurement of the **volume** of glass needed. At the end of this section there is also a description of how to use these methods to calculate the **weight** of glass.

Method 1: Using an impervious model

For this method, the model needs to be impervious to water, and, if it is hollow, it also needs to be sealed so that no water can get inside. Seepage will lead to an inaccurate measurement.

NB: You can follow this method without using any unit of measurement at all, just your eyes to see the differences. If you wish to use units, I suggest metric measurements throughout as these are easier to calculate.

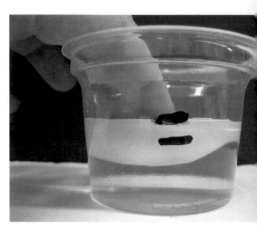

1. The wax model and a cup of water with a mark on the side.

Step1
Take a clean container of clear or translucent plastic, big enough that your model will fit comfortably inside.

Step 2
Fill the container with water, making sure there will be enough to completely submerge the model. Make a mark on the outside of the container exactly at the top of the water level with a permanent marker or chinagraph pencil (see **image 1**).

NB: You may need to hold lightweight models down in the water to prevent them floating. Any part of the model left exposed above the surface of the water will lead to an inaccurate measurement.

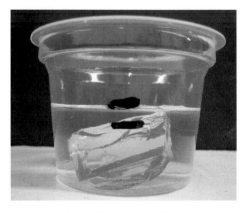

2. The wax model submerged in the water before a second mark is made.

Step 3
With the model held under the water if necessary (see **image 2**), make another mark at the new water level. Then remove the model from the water.

The difference between the two marks on the side of your container is the *volume* of glass needed to fill this particular mould (see **image 3).**

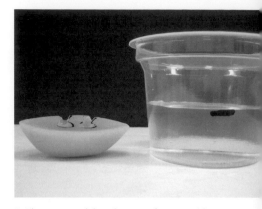

3. Pieces of glass in the water showing that the level has risen back up to the second mark.

Step 4

You can then place pieces of glass directly into the water. Once the level has risen to the second mark, there is enough glass to give a complete casting. Take care to be accurate, as any glass which is not below the level of the water will not be part of the measurement.

NB: Always add extra glass to facilitate casting. About 10% extra allows for any flashing and for air bubbles that may rise to the top surface of the glass; these can be cut or ground away. In some cases a particular form may require quite a lot more glass to provide extra pressure to complete the casting (see Chapter 1: Kiln-casting Glass, and Chapter 8: Core Casting).

Method 2: Using a wet mould

This method of water displacement uses a wet or very damp refractory mould. It can be freshly made (for example, a mould right after the wax has been steamed out) or an exisiting mould which has been doused with water. In both cases the mould is still essentially wet and will not absorb water. If the mould has begun to dry out, it will take in water and the water displacement measurement will not be accurate, in which case use method 3.

Step 1

Select a clean bucket or container and pour in more than enough clean water to fill the mould. Make a mark with a permanent marker pen or chinagraph pencil at the water level.

Step 2

Pour water from the bucket into the mould until the cavity is full. Judging by eye, add about 10% extra by volume.

NB: It is not necessary to fill the whole reservoir, as this would become solid glass during casting, which would then have to be removed. Discard the water from the mould, and leave it to dry.

Step 3

Make a second mark at the new water level. The difference between the two marks on the side of the bucket is the *volume* of glass needed to fill this particular mould.

Step 4

Follow the same step 4 as in method 1, adding glass to the bucket up to the second mark.

NB: If the mould leaks, the water displacement measurement will not be accurate, so you will need to fix the leak and measure again. But it is better to find any leaks at this stage rather than later, when it is already in the kiln and full of molten glass (See *Troubleshooting* at the end of the chapter).

Method 3: Using a dry mould

This is a useful method for large-scale moulds which are difficult to lift, or for dried or pre-fired moulds. Fired moulds must be kept completely dry or they may be ruined, as the mould mix will disintegrate in water after firing.

If your mould is a tall or unstable shape, support it while you carry out the water displacement process.

NB: This may be an indication that the mould will also need support in the kiln during firing (see Chapter 9: Mould-drying, Kiln-packing and Firing).

Step 1
Find a plastic bag with no holes in it. It needs to be large enough to overhang the top of the mould so as to protect it from water, and flexible enough to tuck into all the internal shapes, or your measurement will not be accurate.

Steps 2, 3 and 4
Then follow the same steps as in method 2, starting with filling a bucket with more than enough water to fill the mould.

Volume to weight
After water displacement, you can calculate the **weight** of glass from the volumetric measurement. To do this you need to decide which type of glass you are going to use. Each type has a different recipe and chemical composition, which affects its weight in relation to its volume (see Chapter 4: Types of Glass). You will also need:

- a sample of your chosen glass
- a calculator
- a notebook or paper and a pen.

Step by step, write down all the measurements you take, as you will need them all. I suggest using metric measurements throughout, as these are easier to calculate.

Sample test
Now follow steps 1–3 of water displacement method 1, as described above, substituting a sample of the type of glass you are going to cast with instead of your model.

The difference between the two levels of water shows the volume of the glass sample – e.g. 1000cc (one litre) (0.04 cu. ft).

Now remove the sample of glass from the water, then dry it and weigh it on clean scales – e.g. 2kg (4.4lb).

Divide the weight of your sample by its volume:

$$\frac{2(\text{kg})}{1(\text{litre})} = 2$$

The figure you have as an answer is the *specific gravity* (also known as relative density) of the type of glass you have chosen.

Using the specific gravity, you can now calculate the weight of glass from the volumetric measurement you took from your model or your mould by water displacement:

volume x specific gravity = weight

e.g. the volume of water displaced is 3.5 litres and the specific gravity is 2.

3.5 x 2 = 7kg

Reservoirs

Once you have measured out the amount of glass needed to fill your mould, you can see that space will be needed to contain it before melting. This extra space in the mould is usually called a reservoir.

Integral reservoirs

For open one-piece moulds, making integral reservoirs can be done by simply extending the form or adding extra depth to the model. This can usually be done with clay or wax, both of which can be easily removed after the mould mix has been applied (see also Chapter 1: Kiln-casting Glass).

On some forms there is an obvious place for the reservoir to be positioned – for example, a flat base or side on the model. On more complex forms, which have texture all over or many limbs or points, it is necessary to locate a suitable place on the model to become the point where the glass enters the mould. Hold the model and turn it around to find the optimal place for the reservoir entry point. This will usually be a protruding area which can be easily cold-worked after casting without the piece losing significant detail, texture or form; it will also be of sufficient size that you can create an aperture big enough for the glass to flow through. (See the section on *Mixing and pouring* (pp. 59–61) to see how to set up a model on clay to create an integral reservoir).

Separate reservoirs

The shape as well as the size of a reservoir is an important consideration. If a reservoir is too large or too wide, it can make the mould top-heavy or

Casting of *Red Tsubaki* by Keiko Mukaide. Example of a separate reservoir made of ceramic fibre, containing glass. Photo courtesy of the artist.

Clay crucibles used to cast glass into moulds, by Heike Brachlow. Photo courtesy of the artist.

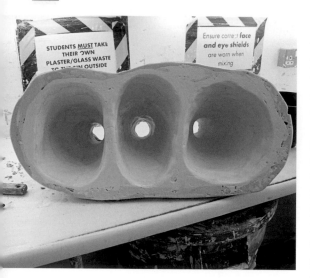

A finished reservoir with three apertures. (For a sequence of images showing how this reservoir was made and reinforced, see Chapter 7: Handbuilding, pp.68-9.)

unstable when filled with glass. In any case the mould needs to carry the combined weight of glass and reservoir, so choice of material and use of reinforcement are important considerations for both reservoir and mould.

Glass for casting is often prepared in the form of billets, blocks or ingots. Having a separate reservoir makes it easier to contain these particular shapes. It is also an advantage for larger-scale work, where the mould and reservoir can be lifted independently of each other, making handling, steaming out wax and kiln-packing easier.

Reservoirs can be made of the same mixture as the refractory mould itself – i.e. various types of mould mix, refractory material such as ceramic fibre, or castable refractories. Flower pots or other unglazed ceramic containers can also be used, providing they will withstand the temperature and duration of the kiln firing.

Reservoirs can be reused as long as they are still sturdy and sound, and providing the same kind of glass is used (as incompatibility problems may arise if different glasses are mixed) (see Glossary, and Chapter 4: Types of Glass).

For particular forms where there is more than one entry point to the mould, making more than one aperture within a reservoir may be required. Making a paper template of the footprint of the top of the mould can help line up the reservoir aperture(s) with the opening(s) in the mould. This may also be necessary if you want to experiment with colour flow, where making a number of different apertures for different colours of glass may give interesting flow patterns within a single cast object.

You will need to experiment carefully and systematically with this method if any level of predictability and control is to be gained (see Chapter 4: Types of Glass, and Suppliers).

In every case, make sure that the reservoir sits cleanly on top of the mould, lined up with the opening and with no gaps and no possibility of movement or slippage during firing. All the glass must be contained in the reservoir without overhanging the sides, or it will melt down the outside not the inside. The base of a separately made reservoir can be hand-lapped using water onto a sheet of sandblasted glass (see Chapter 13: Surfaces and Finishes).

NB: For complex shapes and core castings, it may be necessary to add extra glass to create pressure, to push the molten glass down inside the mould and bring air bubbles up and out. This is called hydrostatic pressure and is the

same principle as a water tank in the loft of a house providing enough water pressure for a shower on the top floor (see Chapter 8: Core Casting).

Setting up for mould-making

Whichever material your model is made from, it needs to be securely attached to the bench or a board to prevent movement during mould-making. The model is usually secured in position with either clay or wax, so that it can be precisely orientated, with the chosen entry point for the glass being the point at which it is fixed to the bench, and with consideration given to the predicted flow of glass into the mould.

Lightweight and hollow models can move or float very easily while the mould mixture is applied, so they may need to be pinned in place using cocktail sticks or short lengths of wire which can be easily removed before firing. Care needs to be taken doing this, so as not to pierce a delicate or thin-walled model, which could allow mould mix inside, causing problems later (see *Troubleshooting* at end of this chapter).

Venting

Venting is a similar system to making runners and risers in metal casting.

During firing, air can become trapped inside the mould and in the molten glass. The result can be either a very bubbly casting, which may cause problems during cold-working, or an incomplete casting.

To prevent air being trapped, tiny channels should be created right through the refractory mould to allow air to expand and escape during firing. The two most common ways of doing this are either using an organic material that will burn out during firing or using wires that can be pulled out before firing (see image 1, p.61).

Regardless of the material used, one end needs to connect to the model, while the other, held in place using small pieces of clay or wax, connects to the cottling or bench top. Once the refractory mould has been made, the material is removed, leaving a clean and continuous channel connecting the cavity inside the mould to the outside atmosphere in the kiln. This allows for air, vapour and any gas produced during firing (e.g. by burning of organic material) to be vented out of the mould before glass casts into it.

Wooden cocktail or satay sticks, drinking straws, waxed string, cotton thread or wool, even grass or straw, all work well and burn out cleanly.

Thread works well if it is tensioned across the model and held securely in place at both ends. You can dip string in wax yourself, which makes it easier to fix to a wax model, and it will part-steam and part-burn out of the mould. You can also buy readymade 'wax string' which steams out completely along with the wax model (see Suppliers).

Wires are easy to use as the fine sharp ends can be gently pushed a millimetre or two into soft clay or wax models.

Grass or straw is more difficult to stick to the model, but tiny blobs of melted wax, or in some cases clay, can be used for this purpose. If these blobs are too big they may create little voids in the mould which can fill with glass during casting, resulting in unsightly 'warts'

which would need to be removed by cold-working. In any case, make sure there is some space between the length of the vent material and the model so as to prevent air pockets being formed when the mould mix is applied (for example, see p.70).

If the model is made of resistant material – e.g. rubber, plastic, plaster or wood – it may be necessary either to use an adhesive to fix the vent material to the model or to drill holes into the refractory mould after the model has been removed. Care needs to be taken in both cases to prevent damage to the model and mould surface. In some cases it may be desirable to make the refractory mould in sections, to facilitate model removal and venting (see Chapter 7: Handbuilding).

Cottling up

Once the model is set up and the venting is in place, then you can cottle up. Cottling means building a retaining wall around the model so that when you pour the liquid mould mix over the model, the mould mix will be contained. It is also a way of controlling the size and shape of the mould form around the model. As far as possible, the mould shape should follow the shape of the model – i.e. a round model would have a round or cylindrical mould, while a rectangular model would have a rectangular or cube-shaped mould.

Linoleum or flexible plastic sheeting are good materials for creating cylindrical moulds, while melamine, varnished or painted wood or sheet glass are good for rectangular or cube-shaped moulds. For certain shapes it may also be useful to use plastic containers and boxes (see images p.61 and Chapter 14: Recycling).

In every case it is essential to have an equal and adequate amount of space between the model and the cottling, and also above the model, to create an even thickness of mould wall on all sides, and to provide sufficient strength and containment for the molten glass. If one side is thinner, this may be a weak point where the mould could crack during firing.Corner clamps can be used with boards to create a rigid box, though these should be slightly loosened as soon as the mould mixture starts to set off or cracking may start to appear in the corners as the plaster expands. Rubber bands, a string tourniquet or tape are also useful for holding the cottling in place.

A release agent such as petroleum jelly (Vaseline) or mould-maker's soft soap is used to make separation of mould from bench or board easier and minimise the risk of damaging delicate edges. The release agent should be lightly smeared on the bench/board surface around the base of the model. Do not apply any to the wider area or this will prevent sealing around the outside of the cottling.

The seal must be complete to prevent any leakage as the mix is poured. Soft clay or plasticine are usually the best materials for sealing as they give a little during mould setting. Do not use clay which is too soft or it will become sticky and weak as it absorbs water from the mix. Sealing can also be done with plaster, though it is not a flexible material, and is also more wasteful as it cannot be recycled like clay and plasticine (see Chapter 14: Recycling).

Poured method of mould-mix application

Pouring mould mix in one go is a straightforward way to make a mould, but not necessarily the strongest. However, for initial projects and small-scale work it is usually the simplest method of refractory mould-making, and provides good experience in terms of handling the materials and gaining a feel for the timing of the mix and application (see also Chapter 7: Handbuilding).

Estimating quantities

Measure the volume of the model (see this chapter, *Water displacement*) or estimate if necessary, and then subtract this from the volume of the box or cottle:

Rectangular box/cottle,
e.g. 10cm x 10cm x 5cm = 500cc
Model = 100cc
500 - 100 = 400cc

So measure materials for 400cc of water (see Chapter 10: List of Mould-mix Recipes).

For irregular-shaped cottles, or if you do not want to do a formal calculation, then you can do a visual estimate as a guideline, using a measuring jug. I use an empty jug and offer it to the mould box/cottling to see how many jugs I need to fill that space. Although this is inexact, your eye and your ability to estimate more accurately will develop through practice.

NB: If you make too much mix then you can use the surplus to make a reservoir. If you do not mix enough, then you can add more providing you rough up

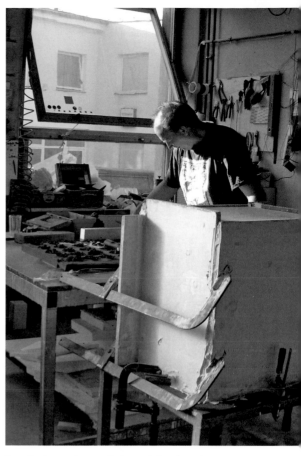

Boards clamped securely to contain a large amount of poured mould mix, with Brian Usher in the background. Photo by Angela Thwaites.

or give 'key' to the surface of the first mix and then make and add new mix as soon as possible (see *Troubleshooting* at the end of this chapter and pp.130–1).

Mixing and pouring

There are two approaches to mixing – wet and dry. Dry mixing is preferable as it improves mould strength through better homogeneity and particle distribution by effectively mixing twice – before and after the materials are added to water.

Wet mixing involves adding dry

materials to water as you measure them out – *never the other way around!* – and then combining them together by stirring. This means you are trying to combine *and* stir at the same time, so the mixture will soon begin to thicken. However, if not done carefully, this can easily lead to lumps and clumps forming, and the mix can also start to 'go off' before you are ready to pour. Poor homogeneity or lumps in the mixture can result in weak points in the mould.

Timing is important with wet mixing, to ensure good results. Once you have started, avoid distraction as much as possible so that you are clear what is happening throughout the process. Use clean utensils, as any remains of set plaster in a bucket or on a spoon will accelerate the setting time of the new plaster mix you are preparing.

Avoid inhalation of any dust from dry materials by wearing a respirator mask throughout, and where possible use an extractor fan to prevent dust particles contaminating the working environment.

Avoid splashing mix in your eyes, and wear eye protection and waterproof gloves wherever possible.

Follow this sequence:

1. Calculate or estimate the amount of water you need to make your mould.
2. Measure out clean water into a clean bucket or rubber mixing bowl.
3. Measure out dry materials by weight or volume into a clean, dry bucket.
4. Combine the dry materials together thoroughly by mixing in the bucket or tumbling in a lidded barrel.
5. Scatter a handful of the dry-mixed materials over the surface of the water, let it settle – *do not stir yet!* Keep adding one handful at a time, allowing the dry material to settle and sink into the water between each handful.
6. Once all the dry material is in the water, allow any air bubbles to rise to the surface. When these have ceased, you can start to stir. Stirring must be done with your hand consistently below the surface of the water to discourage the inclusion of air. Stir continuously to create a homogenous mix and also to prevent material sinking to the bottom.
7. Once the mixture has thickened to the consistency of runny custard or single cream, you can pour it. Pouring must be controlled and not too fast, to limit splashing and prevent air bubbles forming in the mould mix. A good method is to run the liquid mix gently down the inside wall of the cottling in an even stream.
8. Once all the mixture has been poured, you can either gently tap the side of the cottling or gently agitate the surface with the back of your hand to bring up any air bubbles.
9. Use a scraper or rectangular metal kidney to flatten the surface of the mix, ensuring the mould will have a flat base.
10. Clean all buckets, bowls and utensils after use so that they are clean and ready for the next mix.

The following sequence of images shows the steps in making a refractory mould:

1. The wax model on clay with sticks for vents.

2. The model cottled and clayed up.

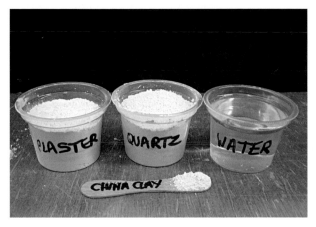

3. Plaster, quartz, water and china clay in cups for mix.

4. Dry materials added to water, slaking.

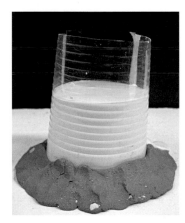

5. The mould mix has been poured.

6. The cottling removed.

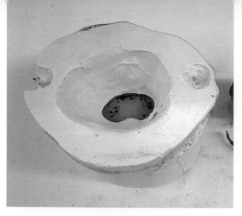

7. The clay removed revealing wax ready for steaming.

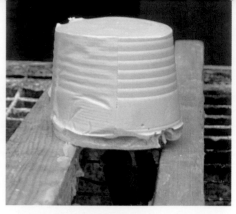

8. The mould turned upside down to steam.

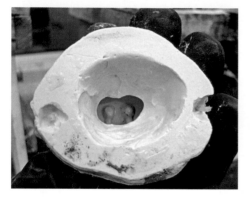

9. The wax has been steamed out, and the mould is clean and ready to be dried.

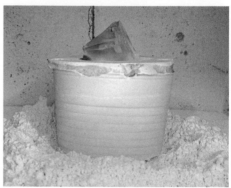

10. The mould in the kiln with glass in it, levelled on a bed of ludo.

Troubleshooting and repairs

Mixing and pouring too early or too late

Mix poured too *early* may mean materials settle and start to separate, resulting in inhibited setting and a weak mould. If you have started to pour and can see the mix is too thin, stop pouring. Stir the rest of the mix in the bowl or bucket until it is a light cream texture, then continue to pour. You could also add crushed ludo (see p.29).

Mix poured too *late* can be too thick to pick up all the model's details of form and surface, and may also trap air bubbles, either way spoiling the casting. If you are struggling to get the mix out of the bucket and it is past pouring,

you can either stop and use the mix to create a reservoir in a rubber bowl (see image p.130), or if it is still soft and creamy you can apply it by hand. This is only appropriate if the model is not fragile and there are no deep undercuts (for application methods, see Chapter 7: Handbuilding).

Not enough mix

If you start to pour and you can see there is not going to be enough mixture to make the mould in one go, there are a couple of remedies. The first thing is make sure you cover the model completely with the first pour, to ensure a good face coat.

Then, chunks of ludo can be added as a filler. Dampen the pieces of ludo

and push them down into the poured mix in areas furthest away from the model so that they are not touching it or disturbing the mix you have poured onto its surface. Subsequent mould mix should be prepared and added straightaway to top up. Make sure that you texture or rough up the existing surface so that the new mix keys into it and attaches well.

Mould repairs

Outside

If your mould has a hole in it, a thin wall or base, or a hairline crack, you can probably repair it before drying and firing.

Dampen the mould, focusing on the area needing repair, but making sure the whole mould is moistened. This helps new plaster-based mix to stick. Cut some strips of fibreglass tape into lengths which are longer than just the area needing repair. Make enough mixture to do the repair in one go, and stir until it is fairly thick. Dip the fibreglass strips into the mix and spread them in a criss-cross pattern across the area to be repaired. Spread more mould mix over the top of the fibreglass and work it around the side of the mould so that it is as even and as integrated into the shape of the mould as possible. Allow it to set, and make sure that this area faces away from the kiln elements when you pack, just in case it still cracks (see Chapter 9: Mould-drying, Kiln-packing and Firing).

NB: Before repairing you may need to cover the hole with cling film or tape to prevent mix seeping inside the mould.

Inside

If you can reach carefully inside, it is possible to fill bubbles, remove lumps, and eradicate flaws from the inside of a refractory mould. However, it is often difficult to access the inside of a mould even if you can see the problem area. It may also be better to leave a small flaw than repair it inadequately or run the risk of dislodging pieces of mould material which will come back to haunt you, floating around in the cast glass. If you are going to have a go at repairing or remedying a flaw, long-handled paintbrushes of different sizes and fine modelling tools are useful for this task.

If the mould is freshly made and you discover cavities or air pockets inside it, you can use a bit of 'dead mix' (i.e. mix which has basically set already) scraped off the top surface of the mould as a filler.

Lay the mould on its side, propping it on sponge or polystyrene blocks if necessary to keep it from rolling. If you can, block up the opening into the mould below the repair point, by gently inserting a ball of paper towel to prevent debris from falling inside.

Wet the area you are going to fill and, using a small modelling tool, press the dead mix into the hole. Use a brush to drop more water onto the repair and wash it further into the cavity. You can repeat this if the mix has sunk below the surface. Once you have built up an adequate thickness, allow the repair to dry and check the inside of the mould for debris before putting any glass in it.

This repair should hold good for small areas – e.g. the size of a pea. For bigger flaws, or cavities discovered later when the mould has already been setting for some time, make a small amount of new mix using the same recipe as the mould itself, and apply as described using a brush and water to wash it deep into the cavity within the existing plaster mix.

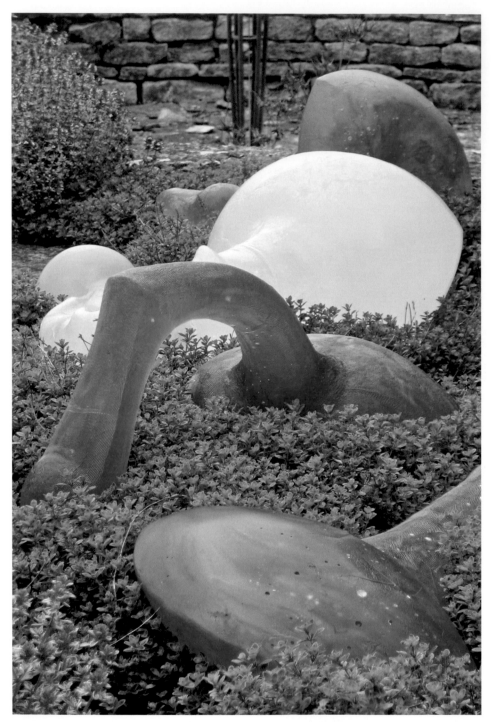

Litter by Angela Thwaites, 2007. Shown at an exhibition at Quenington Old Rectory, Gloucestershire. Recycled from blown glass, largest piece dia: (approx.) 45cm (17¾in). Photo by Angela Thwaites.

HANDBUILDING

Alongside pouring, handbuilding is a valuable way of making a refractory mould. Many practitioners are using handbuilding methods, which are particularly useful for large-scale work where pouring in one go would be difficult. Cottling up and pouring on a large scale not only takes a long time to set up, but can lead to leaks and loss of mixture, over-thick areas of mould mix which prevent heat penetrating the mould evenly during firing, and waste material.

I also use handbuilding for 'lost vegetable' casting when mould-making directly onto an organic object or material (as described below), and for *pâte de verre* (see Chapter 12: Fusing, Slumping and Pâte de Verre).

In both cases handbuilding a refractory mould in layers has a number of advantages:

- ease of application
- ease of removal after firing
- even mould thickness
- even heating and cooling
- ease of incorporating reinforcement
- less risk of cracking across layers
- more efficient use of materials, time and energy
- longer potential working time with mix.

It is possible to handbuild with just about any recipe providing you

know your ingredients. The main considerations are mixing (so that materials do not separate during application), the application method and the setting time. Generally, you will have more rather than less time to apply the mixture, as you can keep pasting or buttering it onto the model long after it has thickened beyond a possible pouring point.

I do recommend using a similar recipe for each layer, so that the layers bond together and contract or expand at similar rates. You may want to add a little china clay to the face coat to lessen the risk of glass sticking to the refractory mould, but otherwise I would stay with a basic recipe and only small variations in proportion of ingredients throughout the making of a mould (see also Chapter 3: Understanding Ingredients and Chapter 10: List of Mould-mix Recipes).

Preparation

You may find it easier and quicker to prepare a bucket of dry mix so that you can then work from this without having to measure out ingredients repeatedly. You must also mix and add the layers in quick succession to ensure that they set at a similar rate. If you delay, you run the risk of the plaster mix in different layers beginning to expand – plaster expands as it sets (see Chapter 3

ABOVE: *Rainman* cast in Gaffer glass using a large-scale handbuilt mould. Angela Thwaites, 2004, ht: 50cm (19 ¾in).

LEFT: *Rainman*.
Photos by Angela Thwaites.

Understanding Ingredients) – or shrink at different rates, and this may cause stress and/or cracking in the mould. So make sure before you start that you have adequate amounts of materials, time and energy to complete your mould in one session.

Always aim to cover the whole surface each time you apply mixture, so that each layer is a consistent thickness and there are no incomplete layers or gaps. This reduces the likelihood of air becoming trapped, helps create an overall even mould-wall thickness, and is easier when de-moulding after firing, as the layers peel off easily and consistently (see image of de-moulding p.121).

Radical changes of recipe and ratio between layers should be avoided, as the differences in material and water content can lead to the layers separating (see Chapter 10: List of Mould-mix Recipes, and Chapter 11: Developing Your Own Recipes and Methods).

The models for *Rainman* and *Elizabeth 1* were about 55cm (21½in) high, and the weight of glass which the refractory moulds had to carry was about 40kg (88lb) each. Handbuilding saves time and mould-mix material, and is less risky during firing than a mould made in one pour, as any cracks forming in the mould body cannot easily migrate across the layers.

Using a turntable speeds up hand-building, as it is easy to rotate and apply the mix at the same time without having to keep moving yourself around the workshop and without having to put things down between applications. A turntable also makes it easy to check that mix is applied evenly on all sides, and to see that no areas are left uncovered by the mixture.

Queen Elizabeth I by Angela Thwaites, 2004. Ht: 50cm (19 ¾in). Cast in a two-part refractory mould, high lead glass weighing approx. 40kg (88lb). Photo by Angela Thwaites.

Through practice and experience you will become accustomed to the setting time of your mix, and from that you'll be able to judge accurately the working time so that no mix is left unused in the bucket or bowl. Flexible rubber mixing bowls are very useful for handbuilding, as any tiny amounts of plaster mix can be easily removed by flexing the bowl over the bin, so that a minimal amount of time is spent cleaning between mixes.

Depending on the material and the surface of your model, there are a number of possible application methods for handbuilding. The ones I have found to be most successful are:

- brushing
- spooning
- buttering/pasting
- flicking
- spraying (see developing your own mixes and methods).

For the face coat (i.e. the first layer directly on the surface of the model on a wax model), I usually use a paintbrush to apply the mix. The best is a soft dense brush, which can hold a lot of mix and be gently stroked over the surface of the model. For intricate areas, I would use a smaller brush and also gently blow the mix into details and undercuts. I might also use a spoon for pouring and flicking mix onto the model. Flicking tends to splat the mix onto the model, pushing air out and away, an action that prevents air bubbles from being trapped close to the surface. Trapped air bubbles would create cavities in the mix, which may then fill with molten glass during casting, leaving the resultant piece with an unpleasant 'warty' appearance.

Reinforcement

For subsequent layers, I would start by spooning mix over the model while the mould mix is still liquid, and then move on to using a spatula or scraper to butter or paste on the mix as it thickens. Reinforcement is easily added between layers. Fibreglass tape, sourced from a DIY shop or builder's merchant and cut into strips, can be dipped into the wet mix and applied in an overlapping criss-cross pattern across the surface of the mould, then more mix is pasted over the top.

When removing the piece from the mould after firing, gloves and a respirator mask must be worn so that none of the small fragments of fibre become airborne or are in contact with your skin (see also p.121 and Chapter 14: Recycling).

I usually add a chicken-wire 'cage' for extra reinforcement between the last two layers of mix. The wire can be stretched tightly around the mould and even pinned in place using steel staples before being covered by the last layer of mould mix. Ungalvanised chicken wire is the best type, as galvanised wire may give off fumes during firing which can be unpleasant and may be toxic if breathed in.

For largish-scale pieces (over 20kg/44lb of glass), I usually apply six layers of mix with fibreglass-strip reinforcement between the second, third and fourth layers, and chicken wire between the fifth and sixth layers. This gives a finished refractory-mould thickness of about 6–7cm (2¼–2¾in).

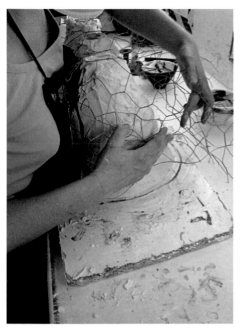

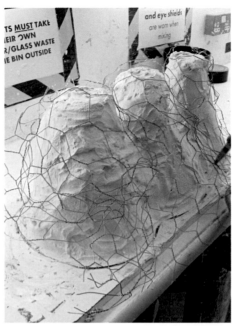

Chicken-wire reinforcement being added between layers of mix.

Wire reinforcement.

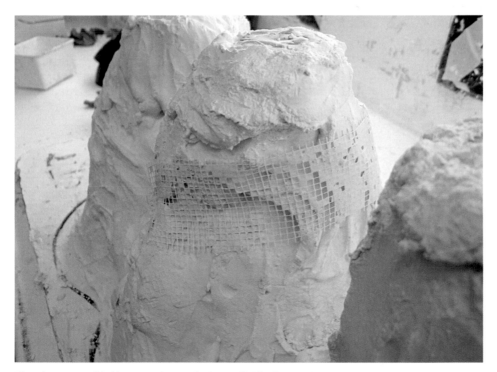

Fibreglass tape added between layers of mix. For finished reservoir see p.56.

KEIKO MUKAIDE

Keiko Mukaide is an international practitioner working with glass. She uses a layering technique for her mould-making. Here is one project created around the idea of camelia flowers.

'Flowers are often compared to a life. For a samurai this was an unlucky association, by the way: the flower of the camellia drops off whole, like a human head falling ...'

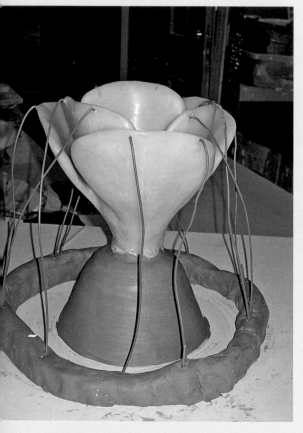
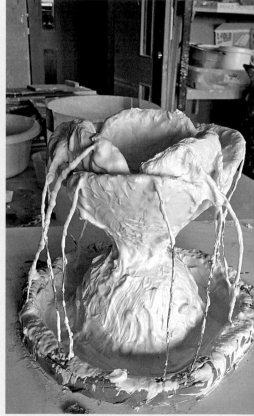

1. A wax model on clay with green wax threads to create vents.

2. The first layer of mix, the face coat, is applied.

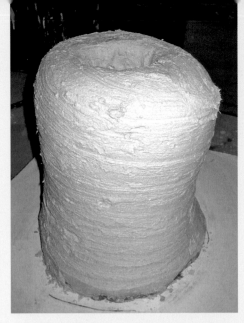

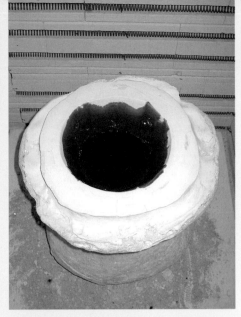

3. The finished mould showing fibres added to the outer layers of mix.

4. The fired mould with glass in it (see also p.55).

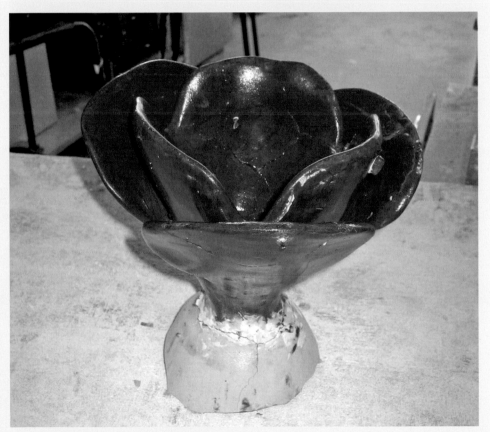

5. Glass casting after being removed from the mould.
Photos courtesy of the artist.

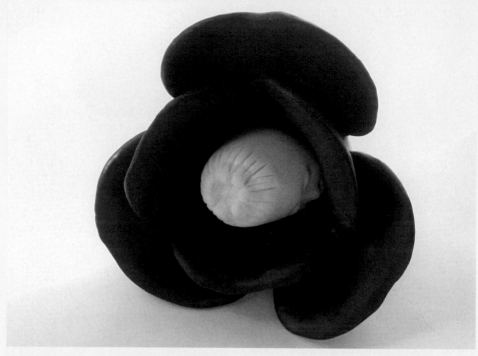

Red Tsubaki, White Camellia, Keiko Mukaide, 2010. Cast glass and porcelain, 18 x 20cm (7 x 8in). Photos by Keiko Mukaide.

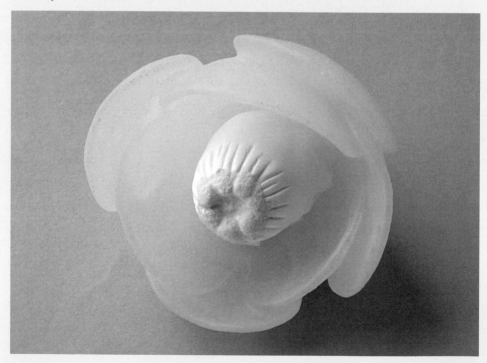

'Lost vegetable' casting

Another very different method of mould-making is by casting from an organic object or piece of organic material. It is a great starting project for gaining experience with mould-making and glass-casting. It shows the full potential for reproducing detail and introduces mould-making ingredients and methods without the need to make a model first.

Ideal organics are relatively small fruits and vegetables, e.g. apples, satsumas, a small cluster of raspberries, broccoli florets, okra, pea pods, baby carrots or new potatoes. Some flower heads are also possible providing they are not so delicate that they wilt or are destroyed when the mix is applied.

Rosebuds are good, and I have also successfully cast carnations by spraying them with hairspray several times before mould-making. The cheapest and stickiest hairspray is the best; apply it evenly all over the flower head and let it dry before spraying additional coats.

Hairspray can also be used on porous items such as small pieces of wood, bark or cork, and some food items such as biscuits and teabags. In some cases a very light coat of molten wax can be applied by dipping. This will help the organic to keep its shape and withstand the water in the mould mix, and can also be used to seal up small holes which could otherwise cause a problem by allowing liquid mix inside the object or form.

Water displacement can be difficult for delicate or porous organics, but putting the object in a plastic bag and quickly submerging it to get a measurement will make sure that you do not underfill your reservoir (see Chapter 6: Mould-making Methods).

I recommend working on a board or bat on a turntable so that you can turn back and forth, applying evenly, checking all the time as you build the layers of mix. Use clay to stick the board to the turntable and to make your reservoir shape, and set the organic on top of it.

For fruit and vegetables, it may be helpful to use a cocktail stick or piece of wire to pin the object into the clay. This prevents it from becoming dislodged while the mix is being applied. If you are casting a flower head, coat the stem in wax and bury the length of it into the clay. Adding wax to the stem means that it will be strong enough to support the weight of the flower head with plaster mix on it, and that the opening into the mould is a big-enough diameter for molten glass to flow through it during the casting process.

A minimum opening of 4–6mm (*c.*¼in) is required if you are using a soft fluid glass, e.g. Gaffer (See Chapter 4: Types of Glass and Chapter 9: Mould-drying, Kiln-packing and Firing). If the stem is too big for your liking after casting, the excess glass can be carefully removed by cold-working (see Chapter 13: Surface and Finishes).

Venting for organics can be done by using cocktail sticks for fruit and vegetables, as the skin can be pierced very lightly by the stick, which helps keep the fruit in place as well as creating a channel for air to escape. For flower heads and food items I use fine cotton thread which can be tensioned across or even sewn right through the item, to provide fine and delicate air channels through the mould (see Chapter 6: Mould-making Methods).

Courgettes cast using lost vegetable method, by Angela Thwaites. Photo by Angela Thwaites.

It is helpful to draw rings on the base board around the object so that you can see how your layers are progressing, making sure that they are evenly and consistently applied and that you measure the height before you start, so that the amount of mix on top of the object is the same thickness as the sides. Remember that what starts as the top, will become the base of the mould, so it will need to be flat and broad enough to stand with stability on a kiln shelf.

You can start applying the mix while it is still relatively thin, using a soft brush or spooning it onto the object. (For the mix for lost-vegetable moulds see Chapter 10: List of Mould-mix Recipes.) Once you have some mix on the surface, it can be blown into fine-detailed or undercut areas using a gentle breath. Do not blow too hard or you may blow the mix off altogether, or damage or disturb your carefully set-up object.

Gradually add the mix, and as it begins to thicken make sure you have covered the whole object with each layer, including the clay for the reservoir. Aim to add two or three layers, each about 5–6mm (c.¼in) thick, to a small object.

If you have a narrow point where the organic object meets the clay for the reservoir, it is necessary to build up a reasonable thickness of mix at this point before applying too much to the object itself. If you don't do this, the object may become top-heavy and crack or break the mould at this narrow point.

The finished mould thickness generally needs to be only about 1.5–2cm (⅝–¾in) on a small organic. Moulds of this size are not going to be carrying a great weight of glass, and the heat will penetrate more easily if the mould wall is thinner, resulting in a detailed and complete casting. If you are making very small intricate items, you may need to adjust the firing temperature and time in order for them to cast successfully (see Chapter 9: Mould-drying, Kiln-packing and Firing).

For pâte de verre you can follow a similar mould-making method to that described here for lost-vegetable casting,

but there is usually no need for venting, as they will by necessity be open moulds (see Chapter 12: Fusing, Slumping and Pâte de Verre).

Burn-out

All organic material must be burned out and any ash removed before glass can be carefully loaded into the reservoir. To do this I usually place the moulds face down in the kiln, raised up on pieces of old shelf or kiln props, and fire up to 800°C (1472°F). A short soak of between 10 and 40 minutes is necessary at this temperature, according to the scale and density of material to be burned out. Wood, pine cones and cork will take longer to burn out than a fine delicate plant or a soft fruit, for example.

After burn-out let the moulds cool down and handle them very gently, as they can easily be damaged after firing. The fired mix is very porous, so don't let the moulds near any liquid or put wet or even damp glass into them – if you do they will quickly disintegrate!

Using a very soft, fine paintbrush or a quick puff of breath, remove any residual ash from the mould before putting glass into it. If any ash remains inside, it will become fused into the glass as it casts, creating unsightly grey/whitish flecks. (For potential cold-working see Chapter 13: Surfaces and Finishes.)

Piece moulds

(For a sequence of images on how to make a mould in two parts, see Chapter 5: Model and Master Mould-making, and for an example of a casting see *Queen Elizabeth I* in this chapter, p.67.)

This method, combined with the handbuilding technique, is useful for making refractory moulds directly around a model where it will otherwise be difficult or even impossible to remove the model from the mould without damage – for example, where a model is made from polystyrene, or has deep undercuts and it is not possible to use the lost wax method.

For a one-off or large-scale model, it is often convenient to let it remain standing, isolate a section, and apply the mould mix by hand in layers. This is most easily done from a clay model, where plastic or metal shim can be gently pushed into the clay, to section off an area at a time. Mould mix is then applied and allowed to set in situ. The shim can be removed, notches or keys made, the exposed edge/surface sealed using soft soap, and the next section of the mould made against the first. This process can be repeated around the model. For best results, use the minimum number of sections possible and create the closest fit you can between them (see p.41).

After all the sections are complete, they need to be carefully separated, the model removed, and the inside of the mould cleaned and checked over before being put back together and a 'jacket' of new mould mix is applied to hold the pieces together. I usually use chicken wire and staples to hold the sections together tightly so that no liquid mix can seep inside the mould.

The seams of this type of mould will probably be visible on the glass casting, and may even create flashing, so it is not a suitable method unless you are prepared to do some cold-working afterwards (see Chapter 13: Surfaces and Finishes).

HANDBUILDING

HANDBUILDING: BERNADETT HEGYVARI

Bernadett made separate moulds for each part of these complex pieces based on human skulls.

'The models were made out of clay. Each of them is made of five different parts that lock together. Each individual part was cast into a plaster and quartz mixture mould, and then I carefully cleaned out the clay. The sheet glass was placed in tightly, and then go! go! into the kiln.'

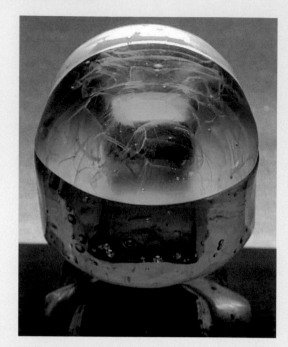

RIGHT AND BELOW: *Hidden Game*, 20 x 20 x 15cm (8 x 8 x 6in). Made out of two different types of window glass.

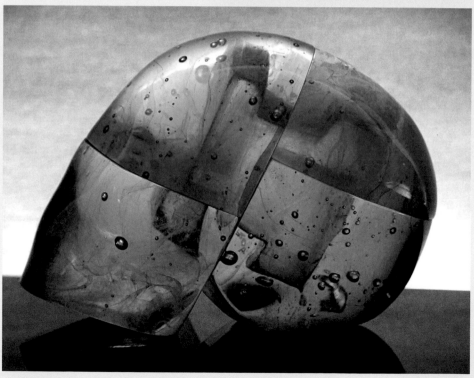

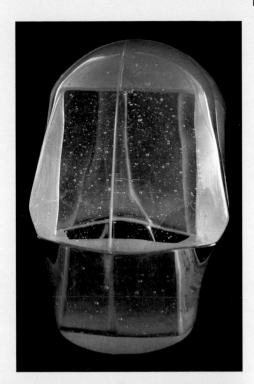

THIS PAGE: *Egypt*, 30 x 32 x 32cm (11¾ x 12½ x 12½in). 'The big head's moulds were made in layers. Banas glass. Much more manageable and a good saver. I put the fibreglass tape into the second and third layer. And they were all pre-fired.'

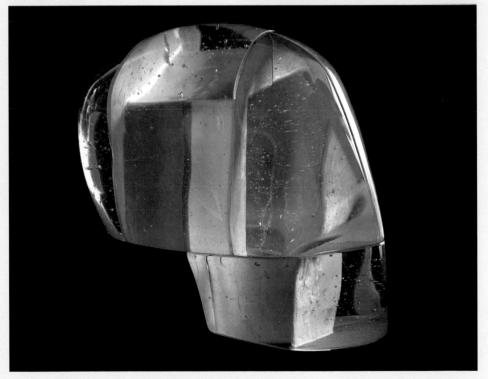

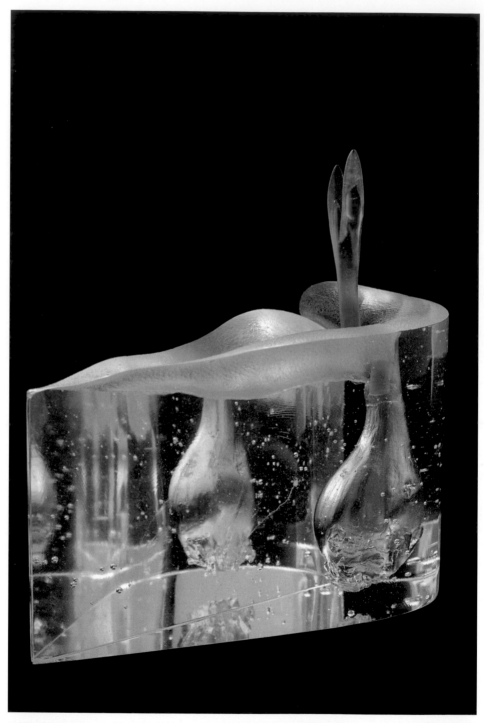

Fertile Landscape, core-cast glass by Max Jacquard. (To see the making process, see pp.82–5.) Photo courtesy of the artist.

CHAPTER EIGHT

CORE CASTING

Core casting is a method of casting hollow shapes, or objects with an internal space, where one shape appears to be suspended inside another. The inside and outside forms may be related or they may be very different to each other.

A clear understanding of basic model- and mould-making is essential for success with core casting, including a very clear ability to track and project positive and negative stages of mould-making. What starts out as the core, made of mould mix, will create a hollow shape inside the glass. So the core is a **mould-mix positive**, and this will create a **negative space**; this is *opposite* to casting solid glass shapes from a **wax positive** (see Chapter 1: Kiln-casting Glass).

In order to get good results it will be necessary to experiment with basics first and then build on this experience to achieve more complex and sophisticated forms. There are potentially many stages of process and a wide range of materials that can be used in core casting. Practitioners spend years developing individual approaches and methods for specific pieces of work, so there are as many variations in method as there are in outcomes.

A core mould made in one piece, where the core is created at the same time as the outer shape, I describe as having an 'integral core'. A core that is made separately, and added into the mould, I describe as a suspended core.

Simple core casting using lost wax

To create a simple mould with an integral core, where the inside and outside shapes are similar: using a two-part mould made in either plaster or rubber, create a hollow wax model by pouring melted wax into the mould and waiting until a minimum thickness of 6mm (¼in) has built up on the inside walls of the mould. Then pour out the excess wax and leave to cool completely.

NB: Using a damp plaster mould is imperative so the wax does not stick to it. It will also cool more quickly than in a rubber mould, which tends to retain heat.

Once you have made and settled the wax to your satisfaction, do a water displacement to measure how much glass will be needed to cast it (see Chapter 6: Mould-making Methods).

Set up the wax model on a clay reservoir with the open side facing upwards, and cottle up, leaving about 3cm (1¼in) equally all around and above the model. You may find it helpful to make a mark on the inside of the cottling so that you can see when you have reached the level when pouring the mould mix.

Core castings have a greater tendency to trap air than solid shapes, so make sure to create two or three vents using cocktail or satay sticks. Then prepare your refractory mould mix (see Chapter 10: List of Mould-mix Recipes).

Once the mould mix is ready, start to pour gently inside the wax model first, letting it fill up and trickle down the outside. This helps to push air out from the inside shape, and also ensures that it is weighed down with mix and will not float away when you pour the rest of the mix around it to fill the cottling. Always pour gradually and steadily to prevent splashing and air inclusion in the liquid mix. Running the mix down the inside of the cottling gives good control. Once all the mix has been poured, gently agitate the surface with the back of your fingers, or firmly but carefully drum your fists on the bench to bring air bubbles to the surface before the mix sets.

Allow the mix to set before carefully removing the cottling, cleaning out the clay and steaming out the wax. Dry the mould thoroughly before loading with glass and firing. You will almost certainly have to soak longer at casting temperature when firing a core casting, in order to allow enough time for the glass to melt, flow down and round the core, and fill up the mould cavity, and also to allow bubbles to come up to the glass surface and escape. (See Chapter 9: Mould-drying, Kiln-packing and Firing).

NB: The molten glass is like runny honey, not water, when it is casting, so try to visualise the glass slowly trickling out of the reservoir, taking into account the size of opening/aperture into the actual mould. From this you can start to think about the length of time needed to complete the glass casting.

Simple suspended-core moulds

As previously stated, there are several ways of approaching core casting according to the kind of inside and outside forms you wish to create. In order to have one shape inside and another shape outside, you will need to prepare models and moulds for each shape before you begin refractory mould-making.

The simplest method of creating a suspended-core mould is to create a core of mould mix around a loop of nichrome wire and dip it into melted wax to create an outer shape. This core can then be set up and the main outer part of the mould made around it.

More complex suspended cores

For more complex and sophisticated shapes, you will need to plan and think through every step in advance. I suggest making sketches of all the steps in the process before starting to make. This will ultimately save time by identifying issues which can be solved before mould-making. Here is a list of key questions:

- Exactly where and how can the core be suspended inside the mould in order that the glass can flow freely down without obstruction?
- Does the core need extra length to provide anchorage and be securely incorporated into the outer part of the refractory mould?

- Does the core need to be pinned into position to prevent movement during firing?
- What route will the glass follow?
- How many and where will the vents be to prevent air becoming trapped around the core?
- Where is/are the reservoir(s) best placed, and what is the size of the opening/apertures into the mould itself?

Stages in suspended-core casting using lost-wax method:

1. Make the core – this is a solid, **positive** shape made in mould mix.
2. Make the wax model – this will be hollow to allow insertion of the core.
3. Insert the refractory core into the wax model.
4. Secure the core in place.
5. Make the outer part of the mould.
6. Steam out the wax.
7. Dry the mould, then load the glass, and fire.

If you make the core in advance of the rest of the mould, it may be necessary to wet it. If left dry, it will suck water out of the new mix, which can lead to cracking developing where the core meets the mould, resulting in potential weakness during casting.

You can use a variety of materials and methods for all stages of core casting (see Chapter 6: Mould-making Methods and Chapter 7: Handbuilding).

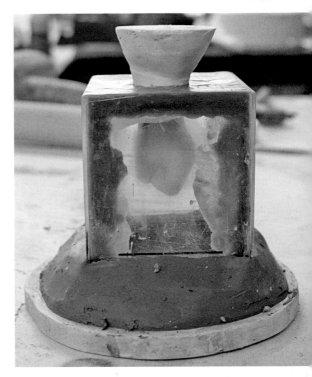

A mould-mix core taken from an alginate mould of a baby's arm suspended inside an acetate model.

A core of the baby's arm embedded inside the poured mould mix showing the cavity to be filled by cast glass.

MAX JACQUARD

Max Jacquard is one of the leading exponents of core casting in the UK. He describes core casting glass as having a 'unique language in the making of sculpture, playing with a visual vocabulary of light and time. It gives two objects in one, where you are looking at one form through the surface of the other; the inside form appears to be an object floating inside the outer one.'

This sequence of images, taken by the artist himself, shows the making of one of Max's *Fertile Landscape* series.

The next sequence shows the making of the 'green shoots' from the actual flower bulbs, which are cast separately and sit into the opening on top of the main core-cast piece, like a stopper sits in a bottle.

1. The core secured into a wax and acetate model with a plaster setter to keep the shape at the base.

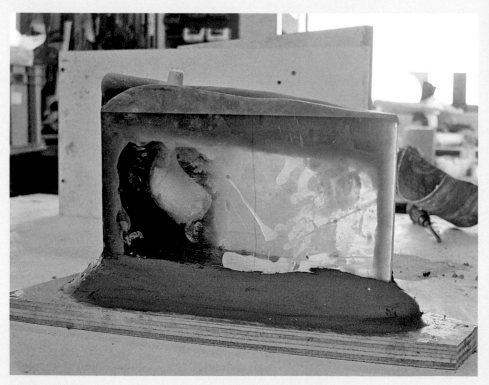

2. Clay is applied all around the base to keep the acetate sheet, base and setter in place.

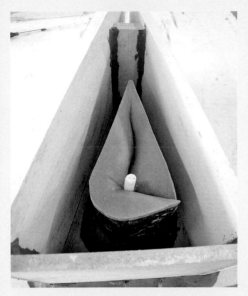

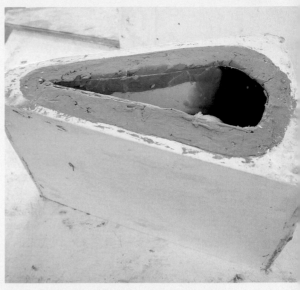

3. The model inside the cottling ready for the mould mix to be poured.

4. The mould turned the right way up after the cottling has been removed.

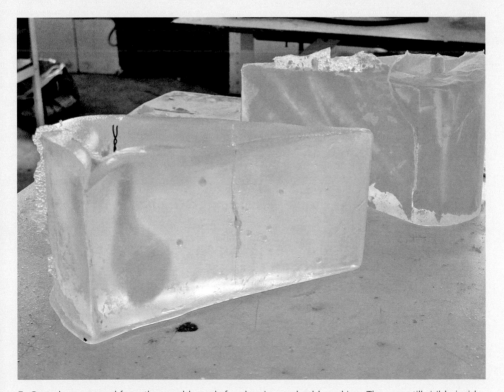

5. Cast glass removed from the mould, ready for cleaning and cold-working. The core still visible inside.

The type of glass Max has used for these last core-cast pieces is Schott LF5 30% lead-crystal glass.

Talking to Max about the mould-making and casting process, it is clear that he, like many practitioners, uses different mould mixes for different pieces of work. For these core casts, he is using a commercially made investment mix from Gold Star Powders, called Gold Star Crystalcast (see Suppliers). Max says it enables him to create complex cores and moulds which are robust, with no flashing after casting, and dissolves away easily in water after firing, leaving a generally good surface on the glass. It is only if the mould surface has been eroded by excessive steaming that traces of the cristobalite in the investment powder may stick to the glass (see Chapter 3: Understanding Ingredients).

For smaller and more straightforward work, Max uses flint and plaster in a 50:50 ratio. He says flint gives a fine grit-free mix which is easily smoothed or worked before firing without loss of surface quality (see Chapter 10: List of Mould-mix Recipes).

You can see more of Max's work in Chapter 12: Fusing, Slumping and Pâte de Verre.

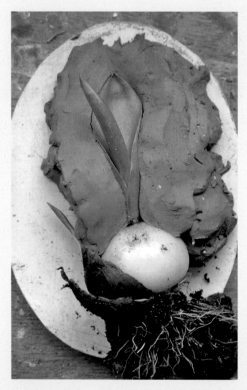

1. A flower bulb embedded halfway into clay.

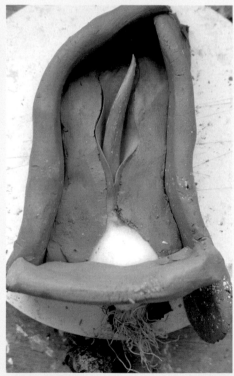

2. The flower bulb set halfway into clay with a clay wall built up over it to contain silicon rubber.

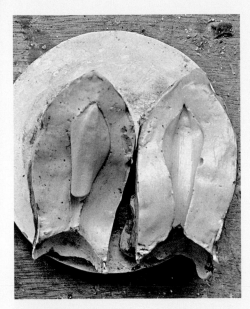

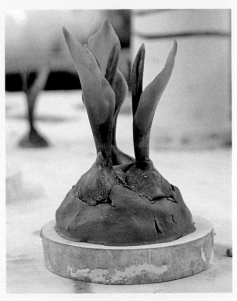

3. Flower bulbs within a two-part silicon rubber mould.

4. Wax shoots ready for refractory mould-making.

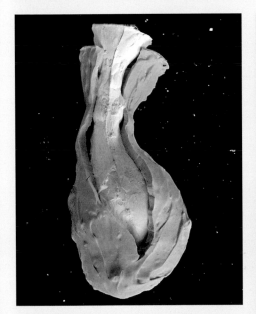

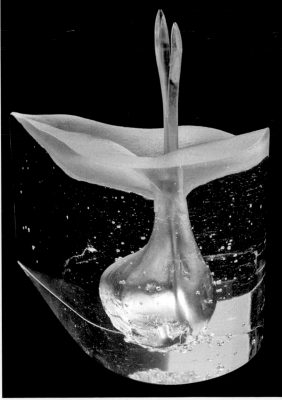

5. A mould-mix core of a flower bulb inside a silicon mould.

6. RIGHT: The finished piece complete with green glass shoots in situ, showing reflected images of the bulb cavity inside the cast glass.
Photos by Max Jacquard.

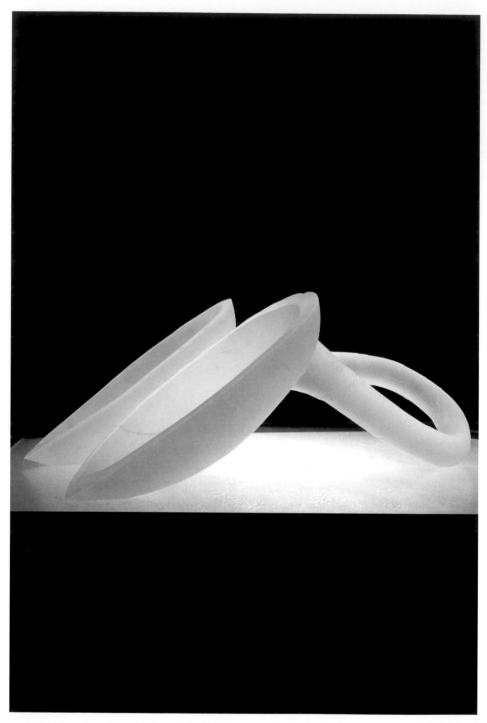

Look here! by Angela Thwaites. Dia: 45cm (17¾in), lost-wax cast in Schott crystal glass. Photo by Robert Taylor.

MOULD-DRYING, KILN-PACKING AND FIRING

Drying and pre-firing refractory moulds

A dry mould is stronger than a wet mould – this is a fact of physics. Water transmits shock, so a mould with a tangible water content that suffers any kind of shock is much more likely to crack than one that is dry.

The worst scenario is if the outside of a mould has started to dry but the inside of the mould body still contains water. When subjected to heat of 100°C (212°F) or over, any water trapped in the mix will expand, becoming steam, and this can certainly lead to spalling – pieces of mould material cracking and falling off during firing. Drying and pre-firing moulds is preferable, but constructing moulds using layers of mould mix can help to prevent mould cracking (see Chapter 7: Handbuilding).

A refractory mould may behave in a very similar way to a ceramic body if fired raw (i.e. straight after making), but Daniel Rhodes goes on to explain in his book *Clay and Glazes for the Potter* (see Further reading) that this method is not appropriate for thick-walled pots. Therefore, I would not recommend it for moulds of any density or thickness, though firing fresh moulds can work well for samples and small-scale work, and may save time.

Firing wet moulds has an impact on the inside of the kiln. It can cause corrosion of the metal parts of the kiln and may also shorten the life of the electric elements. It is therefore recommended to keep the vents or bungs of the kiln open during firing to allow moisture to escape and to minimise potential kiln damage.

I would recommend drying moulds as much as is practical before any firing takes place. This can be done in a drying cupboard if you have one, though doing so will create additional electricity consumption. Moulds can be air-dried effectively before firing, though this may take a long time if they are large and dense. The temperature and humidity of the studio/workshop environment have an effect, and may need to be controlled in order to make this viable. Lhotský s.r.o in the northern Czech Republic cast glass on a monumental scale, and moulds take weeks or sometimes months to be dry enough to go into the kiln. Zdenek Lhotský says that it is actually quicker to dry out the moulds in winter, as this is the drier season in the mountainous region of Železný Brod where the glass-casting workshop is situated.

For small-scale work, I normally utilise heat from the kiln. Moulds can be carefully set up on the roof of the

Moulds drying above kilns, Lhotský s.r.o, Pelechov, 2000. Photo by Angela Thwaites.

the risk of mould mix sticking, gives a much better surface on the resulting cast glass, and reduces the likelihood of devitrification.

Pre-fire moulds empty, and plan to move or handle them as little as possible after the firing. If the moulds are smaller, then pre-firing a group of them together makes the best use of time and energy (see also Chapter 7: Handbuilding).

Pre-firing is used and recommended by a range of glass practitioners, including Charles Bray in the UK and Jan Hein Van Stiphout in the Netherlands. Bray, in his *Dictionary of Glass: Materials and Techniques* (see Further reading), states, 'When a plaster based mould has [air] dried it is essential to pre-fire it gently to about 100°C (212°F) to remove any moisture before actually using it for the casting process.'

Jan Hein takes this further by pre-firing moulds to a higher temperature than that of the glass melt itself. This ensures that all the water has been driven off, all the ingredients in the mix have completed changes that take place during heating up, and that moulds are strong enough in refractory terms to withstand the firing. Importantly, it also gives the very best surface to the cast glass (see also Chapter 3: Understanding Ingredients, Chapter 13: Surfaces and Finishes and p.96 drying program).

kiln while it is firing. They must be raised up and evenly supported on bricks or kiln props. A rack can be made for mould-drying, but in all cases maximum air circulation around the moulds must be allowed, otherwise they may dry unevenly; uneven drying can cause warping and stress, resulting in weakness or even hairline cracking (see also Chapter 14: Recycling).

As well as through air-drying, moulds can be pre-fired, which can greatly reduce the risk of splitting during a casting firing. It also reduces

Preparation and kiln-packing

Measuring the inside space of the kiln you are going to use *before* mould-making ensures that your moulds will fit in. Before packing, double-check that your moulds are dry and have:

- flat bases
- even wall thickness
- adequate reservoir capacity
- no cracks, holes or weak points.

Prepare the inside of the kiln, the shelves and the furniture with bat wash and allow them to dry before use. Plan the position of the moulds as much as possible so that you do not have to keep moving moulds around, especially if they have glass loaded into them already. This minimises the risk of dust and pieces of mould mix falling down inside.

Prepare the glass, if you have not already done so, and check that it is clean and dry. If at all possible, load the glass into the moulds and reservoirs *after* you have packed the moulds into the kiln. This is safer in handling terms, as you will be less likely to scratch or snag your fingers on sharp bits; the glass is less likely to move around inside the mould, which could cause surface damage or bits of mix to break off inside; and the moulds are much lighter and easier to manoeuvre into the kiln.

As a defence, I often prepare kiln shelves with a bed of sand or ludo powder pushed up at the sides to create a moat. This means that if a mould does crack and glass leaks out, its flow inside the kiln is inhibited, and shelves, furniture, elements and brickwork are protected from the damaging effects of molten glass. The sand/ludo bed also allows moulds to be sensitively positioned and levelled before firing. Move the mould into position carefully and then gently slide it side to side, checking with a spirit level. Make sure that the mould is evenly supported by the sand/ludo

underneath, and if necessary bank it up and reposition the mould before checking the level again. This is also vital for slumping, where a set-up which is not perfectly level can result in glass sliding off the mould completely.

Before packing, make sure the inside of the kiln is clean, and free of any glass debris or potential contaminants – e.g. small pieces of reinforcement material or metal. If the kiln has been used for firing lustres, enamels or silver stain, it may be good to fire it up empty, with the bungs and vents open, to ensure there is no residual fume from binders, silver stain or painting medium which could volatilise into the atmosphere. After firing, where you have used silver stain, you should dispose of any plaster/ludo used.

As a general rule it is better to leave space between moulds. However, if they are small, this can be kept to a minimum so that the pack makes efficient use of the kiln's capacity.

NB: A kiln which has been used repeatedly to fire silver stain and lustres may continue to release contaminants from kiln brickwork which may affect the surface of any glass fired in it.

If you aim to fire a number of moulds in one go, you may need to stack the shelves and pack densely. This will affect the air and temperature flow inside the kiln during the firing. Make sure each of the shelves is level and balanced. You may well have to adjust the ramp and soak times of the firing to allow for everything in the kiln – that means the shelves, furniture, brickwork, moulds and glass – to reach the same temperature. Longer annealing may also be needed (see below for description of firing schedules).

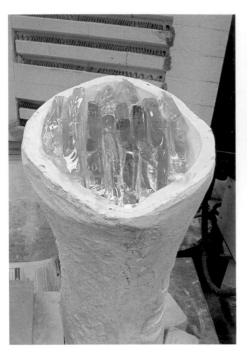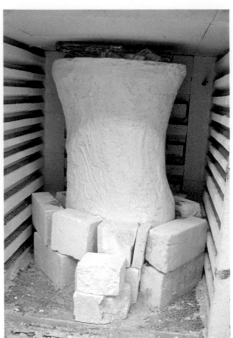

Penelope packed with glass and going into kiln. Photos by Angela Thwaites.

As stated above, if I have pre-fired large-scale moulds, I would aim to leave them inside the kiln and handle them as little and as carefully as possible. I check that they are sound, and then gently slide them forwards or lean them over while supporting them, to load glass inside.

For moulds like these and any larger ones, especially if they are tall, I would reinforce them while mould-making (see Chapter 6: Mould-making Methods) and support them during firing. The taller the mould, the more vulnerable it is to shifting during the firing, as it may be top-heavy with glass in it, and the hydrostatic pressure is greater when it is full of molten glass. This means that the glass behaves like a column of water, and can easily burst the sides of the mould if this has not been strongly constructed or supported. Old pieces of kiln shelf

and kiln or HTI (high- temperature insulation) bricks can be packed around the mould once it is in situ. Some practitioners go as far as encasing the entire contents of the kiln by pouring mould mix in and around moulds, shelves and bricks, to prevent any movement or the possibility of the mould splitting. This is an extreme approach, however, and one which I think most makers will not need to adopt.

The kiln

Getting to know your kiln is also a very important factor. The quantity of material inside the kiln, including glass, moulds, kiln furniture and the brickwork itself, has an impact on the firing. Pyrometric cones can be set up

in several locations inside the kiln to find out if there are any cold spots, or a significant heat differential between top and bottom. If there are any differences in temperature, firing much more slowly should help to develop a more even heat throughout the firing chamber.

Moving or removing shelves and props has an impact as it changes the air- and heat-flow through the kiln chamber. It may be necessary to experiment with different packs and layouts of kiln furniture and moulds to achieve optimal temperature balance. Contemporary kilns made for glass often have zone control, which can give easier and more accurate temperature control.

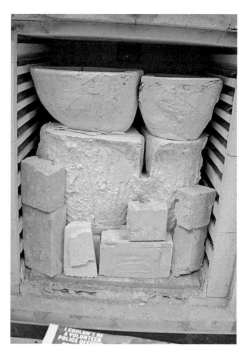

A mould packed in the kiln supported by bricks and pieces of ludo. See final pieces on p.64. Photo by Angela Thwaites.

Writing the firing cycle

I like to write the firing cycle and program the kiln controller ahead of time, so I can consider any necessary changes that might become apparent while I pack the kiln and load the glass. Then I double-check for any mistakes before running the program.

Glass is a bad thermal conductor, which means it is slow to heat up and cool down, and will not tolerate thermal shock – i.e. rapid changes in temperature. It is therefore necessary to control the entire firing process in order to work successfully with kiln-formed glass. Developing firing cycles or schedules to carefully create and maintain even kiln temperatures reduces the risk of stress and strain developing, and therefore minimises loss. Failure to control kiln-firing usually causes stress and strain to build up inside the glass, which when released results in cracking.

Important considerations for developing a firing cycle are the thickness or mass of the glass and mould, and its shape. Larger-scale pieces need considerably more time in all phases of firing, but not necessarily higher temperatures.

Developing a firing cycle is particularly challenging when working with complex shapes which have very thick and very thin areas within them, or hollow forms with a mould-mixture core inside (see Chapter 8: Core Casting). Complex and geometric shapes with sharp corners and/or sharp changes of angle are particularly vulnerable to developing stress, which can lead to cracking if insufficiently annealed.

Annealing

Firings for casting glass are usually the longest and slowest of the kiln-forming cycles, as the glass is required to melt and flow to take up the shape and detail in the mould, and this takes both heat and time. It is also necessary to anneal the glass for a period of time after it has cast into the mould, and to control the cooling phase of the firing cycle (see Glossary and graph and table below at the end of this chapter).

Annealing is basically a process employed to reduce the potential for permanent internal stress developing in the body of the glass. It takes place over time through what is called the transformation range of temperatures. Annealing involves a controlled process first holding temperature and then slow, gradual reduction in temperature from a high to a low point. The upper temperature is usually called the annealing point – the glass is not visibly moving at this point; and the lower is the strain point – no permanent strain can be introduced below this point, though the glass may still crack if subjected to thermal shock. Careful monitoring and control within this range is essential for successful annealing and therefore overall success in casting glass.

The manufacturer and supplier should be able to recommend temperatures for the melting, annealing and strain points for the type of glass you have chosen to use. Given this range of temperatures, you can develop a firing cycle for the object you are going to cast in glass in the mould you have made (see Suppliers, Further Reading and Chapter 4: Types of Glass).

Phases of a firing cycle for casting

The sample graph at the end of this chapter shows the times and temperatures for a casting firing. Here the same firing is described in sequential phases. The number of phases in a firing may vary according to the type of glass, the scale and the shape of the piece(s) to be cast.

Initial heating up

During the heat-up, any residual water is driven off, so vents should be partially open to allow steam to escape. It is vital that all water vapour has gone before the glass melts, otherwise de-vitrifcation can occur and the mould may start to crack or split open. A reasonable rate of climb for this phase is 75–100°C (167–180°F) per hour, though this will vary according to the scale of the work (See *Drying and pre-firing refractory moulds*, at the beginning of this chapter).

Curing of the mould

Using a mould-mix recipe based on a combination of plaster and silica, the final water of crystallisation goes out of the mould mix, and quartz inversion takes place, at 573°C (1063°F) (see Chapter 3: Understanding Ingredients). The mould is then cured, ready to receive the molten glass.

Casting

The speed of climb to top temperature can be set at a slightly faster rate than the initial heat-up, e.g. 90–150°C (194–270°F) per hour, but time does need to be allowed for everything in the kiln chamber to reach the same temperature, so larger-scale work will

need a slower rate of temperature climb.

As the glass in the reservoir or mould heats up, the viscosity decreases, and it softens and then melts and flows. This casting temperature is usually held, or 'soaked', for a period of time to allow all the glass to flow out of the reservoir and into the mould in order to fill up the entire shape. Typically, the casting range is 800–860°C (1472–1580°F).

Top temperature

After the casting soak, another fast ramp up to a slightly higher temperature is programmed – e.g. 500°C (932°F) per hour up to 850°C (1562°F). A shorter soak at this top temperature will homogenise the molten glass, relax it into the mould details, and allow air bubbles to travel up through the glass to the top surface, which will level out at this point. The length of soak time is determined by the type, thickness and mass of the glass and the shape and condition of the mould. If the mould is showing signs of heat stress – hairline cracks, low-level spalling – then the top soak should be as short as possible to reduce the risk of the mould failing.

Cooling and annealing

At the end of the glass-casting process, cooling begins, usually with a 'crash cooling' phase. This means opening the vents and the kiln door to allow free flow of air throughout the kiln, giving a rapid reduction of heat to around 550–600°C (1022–1112°F) (and also saving energy, as the power input is temporarily stopped for this phase of the firing). This helps to avoid loss of surface quality and devitrification, which starts to occur above 700°C (1292°F) depending on the type of glass used. The glass viscosity

increases as it cools down, movement slows, and the risk of shape change and leakage are reduced. However, it can take an hour or more to lose this heat, depending on the scale of the work and the airflow. NB: It is important to remember that the temperature readout is the *air* temperature in the kiln and not the *glass temperature*, so you will need to allow more time for the glass to cool.

Make sure that the kiln controller you are using does not wipe or lose the program during the crash cool, as some have a safety cut-off system which is activated when the door of the kiln is left open. Make sure, too, that the temperature does not drop to or below the annealing point (the top of the transformation temperature range), as this can have disastrous results. Some types of glass have a tendency to pull back from areas of the mould surface if the temperature drops too quickly during crash cooling, causing an unsightly dimple. This is usually called 'sucking in'. (see Glossary and Chapter 4: Types of Glass). Cooling more slowly down to the annealing point at the top of the annealing range helps to reduce this tendency.

Once the kiln is at about 600°C (1112°F), gradually close the door and vents and watch carefully until the annealing point is reached and the annealing soak established.

The actual glass temperature needs to remain constant during the annealing soak, e.g. 440°C (824°F) for Gaffer casting crystal. After the annealing soak (see Glossary), a slow ramp rate is instigated to continue controlled cooling down to the strain point. The strain point is usually about 120–150°C

(216–270°F) below the top annealing point. For example, for Gaffer glass the annealing point is 440°C (824°F) and the strain point is 318°C (604°F), for Bullseye Glass the annealing point is quoted as 482°C (900°F) for thick slabs or castings, and the strain point 371°C (700°F) (See also Further reading).

Once the temperature reaches the strain point, the next ramp rate down can be twice or three times as fast as the previous one as no permanent stress can be introduced at this point, though thermal shock still presents a risk. Ramp rates for cooling vary greatly according to the scale of the work in the kiln and the type of glass. Consult your manufacturer or supplier for specific temperatures and recommended rates.

For smaller work, I would end the program at 150°C (302°F) and then allow the kiln to cool 'naturally', i.e. at its own speed. For large work I would continue the program to control the temperature right down to about 50°C (122°F), as the actual temperature of a large mass of glass can be hotter than the pyrometer readout.

For smaller work, if you open the kiln door and you can put your hand on the glass without it feeling uncomfortably hot, then you can take it out without too much risk. I would still wait till it has cooled down significantly before removing it from the mould, and even longer, preferably overnight, before washing or putting water on it (even then it is wise to use tepid not cold water). In a cold workshop in winter it is better to wait until the temperature is well below 30°C (86°F), to avoid any risk of thermal shock.

Large-scale work I leave in the kiln until it reaches ambient temperature, and once it has been de-moulded I wait several days before washing it, as the glass may still be a higher temperature deep inside its mass.

A small kiln will cool down more quickly than a large one, so making notes of times and temperatures will enable you to predict the time needed for the temperature to cool sufficiently to allow the kiln door to be opened.

Kilns and controllers

Getting to know your kiln and your programmer or controller is vital. There are many different types and models of both on the market, with a variety of features.

The number and positions of the heating elements, size and shape of the firing chamber – all have an effect on how the kiln fires. The ideal for casting is elements around all sides and in the top and base of the kiln to ensure the most even heat possible. Slumping kilns often have elements only in the roof, so that the surface of the glass is heated directly and immediately.

Most kiln controllers are now computerised, and many of them can be monitored remotely on a PC. Some controllers need to be programmed using a ramp rate of degrees per hour, or temperature over time, and some function using accumulative time. Most kilns will have a controller when you purchase them new, but you may have a choice, so researching the most suitable type for you and the work you want to do is essential.

Contemporary kilns often have continuous relays which avoid any changes in power input and maintain a constant temperature, but many kilns still have

contactors that cut the power in and out, which can result in temperature fluctuation. If the fluctuation is more than one or two degrees either side of the set temperature, it may be problematic for larger-scale work, so take this into consideration when planning firings and using or buying new equipment (see Suppliers).

Documentation

Always monitor and record your firings, to develop an understanding of the process and the results, and also to detect any deviation from the program, or any problems, at an early stage. This can be done both by opening the door of the kiln to have a look at various points, and by watching the temperature readout. Working with hot kilns is a high-risk activity, so *be safe* and protect yourself.

Never open the door during the annealing or cooling phases, as a rush of cold air can be enough to cause thermal shock which can result in the glass cracking. Having a look once the casting temperature has been reached will assure you that your mould is still in good shape, and checking again during the casting soak is also a good idea, especially if you are making a new form, using a different type of glass or in the early stages of building your experience. The more you look, the more you will see and understand what is going on and how to work with it. Taking 'before and after' photographs alongside written notes is the best way to chart progress, build knowledge and create reference material for future work.

Problems and troubleshooting

If you are going to attempt intervention or rescue, always turn off the power, wear protective clothing and eyewear, and have someone else there to open and close the kiln door. In any case, you will need to work quickly, as the glass will stiffen up fast as it cools down.

Think before you act and do not take risks with either yourself, the equipment or the work.

Mould failure during firing

Once a mould starts to split, a crack can develop and this can result in glass leaking. If unchecked, this can lead to an incomplete casting. In the worst case, the mould may split open completely and all the glass flow out. To reduce the risk of cracking or splitting, it is better to make the mould in layers (see Chapter 7: Handbuilding).

However, if a leak is caught in time it may be possible to limit the damage. If you see a crack in the mould which is developing into a leak, crash-cool the kiln immediately until the glass has stopped flowing, stabilise the temperature and then anneal and cool as planned. There may be some flashing as a result, but this can be removed through cold-working (see Chapter 13: Surfaces and Finishes). If you abort the program and do not anneal the piece, it will certainly have a high level of stress in it.

Mould overflowing

There are several reasons why this might happen:

- There is too much glass in the reservoir.
- There is an air blockage and the glass is prevented from moving down into the mould cavity.
- The mould has shifted and is leaning to one side (see section above, *Preparation and kiln packing*, p.88).

These issues are difficult to resolve during firing and are best addressed by prevention. I recommend measuring the glass as accurately as you can using water-displacement and venting moulds with complex shapes where air may become trapped (see Chapter 6: Mould-making Methods).

If you suspect that air is trapped, try raising the top temperature by 15–20°C (27–36°F) and soaking to make the glass more fluid. You will be able to see if bubbles come to the surface. However, this approach can risk heat-stressing the mould – so do not soak for too long (try 20–30 minutes) without having a quick look – though it may work for smaller pieces where the air can escape more quickly and easily.

Drying program for mould for 'Penelope & Odysseus'

Description	Rate °C/hour	Temperature °C	Soak time (hours)
Ramp up	35	100	2
Ramp up	50	200	2
Ramp up	75	300	2
Ramp up	75	400	2
Natural cooling	0	0	End

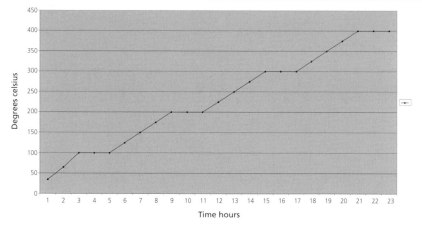

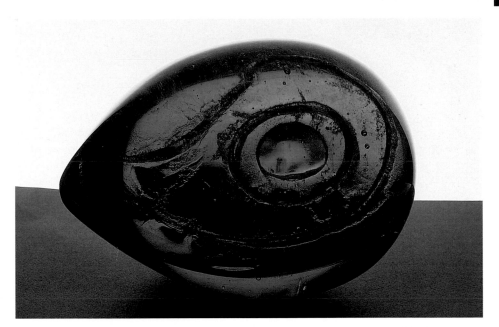

Amber Eye by Angela Thwaites. L: approx. 28cm (11in). Cast in two halves in open moulds, then sandblasted and refired to a high fuse, creating air-trap decoration. Photo by Robert Taylor.

Casting programme for *Penelope and Odysseus*

Description	Rate °C/hour	Temperature °C	Soak time hours
Ramp up	75	600	2
Ramp up	90	840	5
Full power	500	850	10 mins
Crash cool	75	600	0
Crash cool	50	495	0
Annealing	15	480	20 mins
Controlled cooling	2	410	0
Controlled cooling	3	360	0
Natural cooling	5	120	end

Time hours

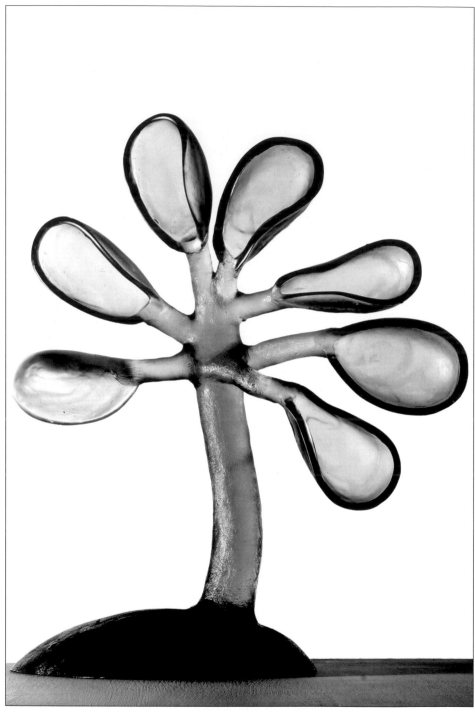

Grey Flower, by Angela Thwaites, 2004. Ht: 35 cm (13¾ in). The refractory mould was applied by spraying. Photo by Robert Taylor.

LIST OF MOULD MIX RECIPES

I suggest reading Chapters 3: Understanding ingredients, 5: Model and master mould-making, 6: Mould-making methods, and 7: Handbuilding before reading this one.

The recipes here are quoted in percentages, and can be translated into metric or imperial measurements according to preference. I find metric easier for calculation.

Ratios and quantities

The recipe of a mould mix needs to be considered together with the ratio of water to dry material and the actual quantity of each ingredient. All these factors together affect the overall performance of the mix before, during and after kiln-firing (For details about mixing, see Chapter 6: Mould-making Methods).

Most practitioners are using a ratio of approximately 1:1.5 and a simple 'half and half' binder/refractory recipe.

Example of a basic recipe

50% plaster
50% quartz or flint

For a 1:1.5 ratio this measures out as:
1 litre water
750g (26½oz) quartz or flint
750g (26½oz) plaster

Using a higher ratio of 1:1.6, or even 1:1.7, gives a denser mix.

A 1:1.6 ratio measures out as:
1 litre water
800g (28oz) quartz or flint
800g (28oz) plaster

This is a good basic recipe and can be used successfully for casting small-scale objects, and will easily withstand temperatures of up to about 870°C (1598°F) and soak times of about 3–5 hours. It can also be used for making slumping moulds (see p.113).

Jan Hein's recipe for lost-vegetable casting and pâte de verre

40% quartz
40% plaster
20% grog

This recipe has a high level of refractory material in it, so withstands twice firing very well. Grog gives a lower shrinkage rate, so reduces cracking during firing.

Ludo recipe 1

32% ludo, crushed to a powder
32% quartz
32% plaster
4% kaolin

This recipe has a high level of pre-fired material (ludo) in it, and thus a lower shrinkage rate, and is resistant

to cracking during firing. However, the ludo and the lower percentage of plaster make it softer. If used in conjunction with the lost-wax method, it is suitable for shapes needing short steaming-out time, e.g. simple, hollow wax models.

Ludo recipe 2

- 33% ludo, crushed to a powder
- 15% quartz
- 15% olivine sand
- 33% Keramicast plaster
- 4% molochite

This recipe, containing olivine sand and a low level of quartz, gives a reduced level of silica dust. Using denser Keramicast plaster helps to reduce steam erosion during the removal of wax. Olivine is very refractory, but it may stick slightly to soft types of glass, or during prolonged soak times at high temperatures. This mix can therefore be used in conjunction with a face coat of the following:

- 32% ludo, crushed to fine powder
- 32% quartz
- 32% keramicast plaster
- 4% molochite

Ludo recipe 3

- 33% ludo, crushed to a powder
- 10% quartz
- 10% olivine sand
- 10% grog
- 33% Keramicast plaster
- 4% kaolin

This recipe, above, using three refractories and ludo, has good variation in particle size, giving a dense and strong mould mix, suitable for high temperatures and long

soak times (see Chapter 3: Understanding Ingredients, and Chapter 9: Mould-drying, Kiln-packing and Firing).

High-temperature recipe

- 33% Keramicast plaster
- 33% ludo (with olivine in it)
- 10% fine silica (quartz)
- 10% grog
- 10% olivine sand
- 4% kaolin/china clay or molochite

Fine surface recipe

I developed this recipe to experiment with spray application. I carefully adjusted the recipe for subsequent layers so that there was a consistency and relationship between each layer's mix, using the finest materials in the initial face coat and first layer and the coarsest in the outermost layer. The result was very good (see p.98, image of *Grey Flower*).

Face coat – thin mix to facilitate spraying on. This has a high plaster content to withstand long steaming. *Ratio 1:1.43*
- 780g (27½oz) Keramicast plaster
- 750g (26½oz) quartz
- 100g (3½oz) kaolin
- 1 litre water

Second coat – poured and brushed *Ratio 1:1.5*
- 750g (26½oz) Keramicast plaster
- 375g (13¼oz) quartz
- 375g (13¼oz) flint
- 60g (2oz) kaolin

Third coat – poured and pasted on *Ratio 1:1.5*
- 750g (26½oz) Keramicast plaster
- 750g (26½oz) flint

Fourth coat – poured, with mesh inside
Ratio 1:1.63

- 540g (19oz) Keramicast plaster
- 540g (19oz) ludo
- 454g (16oz) flint
- 90g (3oz) olivine sand
- 1 tablespoon of chopped fibreglass strand

Research recipes

Gabriel Argy-Rousseau's recipe from Janine Bloch-Dermant's book is quoted as containing:

- 28% modelling plaster
- 12% calcinated and pulverised kaolin
- 10% ground sand
- 37% grains of sand
- 13% sifted asbestos

At the RCA, we substituted fibreglass for asbestos, and a mix of quartz and olivine sand instead of the ground and grains of sand in the original recipe. This worked extremely well.

- 30% potter's plaster
- 30% olivine sand
- 20% molochite
- 10% quartz
- 10% kaolin
- + fibreglass

This recipe proved to be one of the best on the project, and a mould was made of a cone shape, which was reused and re-fired successfully a number of times without loss of surface quality or refractory strength.

A variation of this recipe is as follows:

- 28% plaster (either Keramicast or dental plaster – potentially closer equivalents to modelling plaster)
- 22% molochite
- 3% kaolin
- 10% quartz
- 37% olivine sand

The Amalric Walter project at Wolverhampton used similar materials for mould-making (see Further reading).

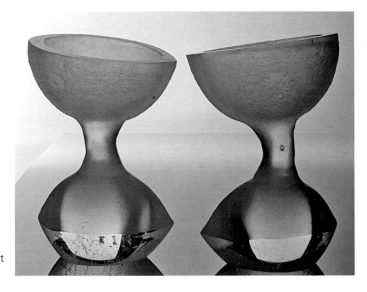

Butterfly Kiss, Angela Thwaites. Ht: approx. 16cm (6 ¼in), lost-wax cast lead-crystal glass, part polished and part sandblasted and brush polished. Photo by Robert Taylor.

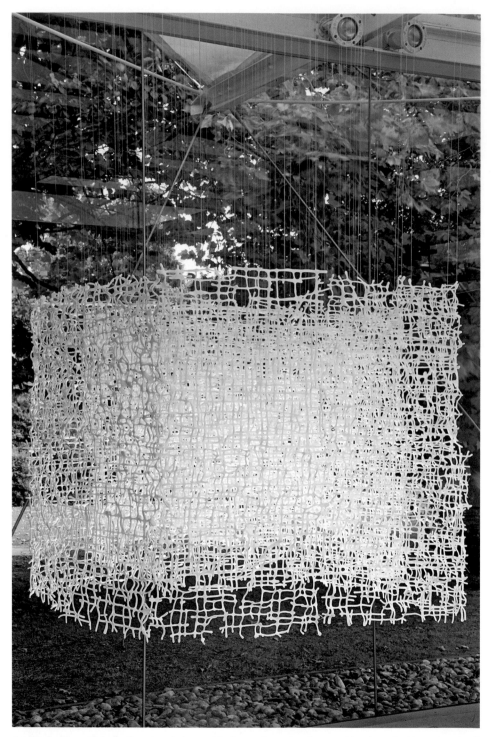

Erosion by Tracy Nicholls. Fused and slumped Bullseye glass over clay moulds. Photo by Simon Bruntnell.

DEVELOPING YOUR OWN RECIPES AND METHODS

Unless you already have knowledge and experience, I suggest you read the first three chapters of this book to familiarise yourself with the materials and principles, followed by Chapters 5, 6 and 7 for application methods.

Once you understand the basics, you can start to develop your own repertoire of recipes and methods. In all cases I would strongly recommend experimenting, initially on a modest scale, and keeping detailed and systematic records at every stage so that you can repeat successes and identify and eliminate errors before introducing new variables. Using new ingredients, even if the quantities are very small additions, may have a bigger effect than you can imagine.

Creating new forms, working on a larger scale, particular details or surfaces, or using different types of glass are all potential reasons for the need to adapt, improve or create a mould-mix recipe and/or method of refractory mould-making.

Results are also a driver – for example, if a mould has failed and you know it needs extra strength or a higher level of refractory capability, then you will need to experiment to find a solution. (See also *Troubleshooting*, p.62, Chapter 6: Mould-making Methods.)

Suggested points for good practice:

- Start by adjusting recipes you already know.
- Observe and record results very carefully, preferably with images as well as written description.
- Do not assume or presume anything.
- Limit variables by only changing one thing at a time; otherwise it is impossible to see or understand the effect of the change you have made.
- Test in series – for example, percentage additions of an ingredient – so that you can see the incremental effects. This can give you a range of recipes for specific uses.
- Be safe – research new materials thoroughly and read manufacturer's/supplier's recommendations for safe use before going ahead.
- Be prepared to learn from mistakes as well as successes, and never say never!

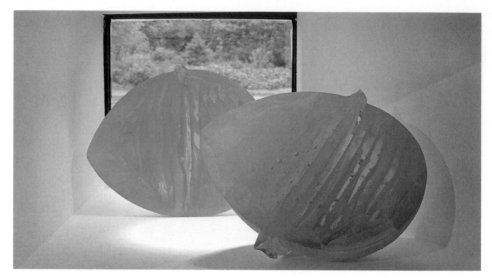

Look See!, by Angela Thwaites, 2005. Float glass, l: approx. 25cm (10in). Photo by Angela Thwaites.

Adjusting the ratio of dry material to water and/or the proportional combinations of ingredients can have a strong effect on a mould mix. Avoid radical changes of recipe and ratio between layers if handbuilding (see Chapter 10: List of Mould-mix Recipes and Chapter 7: Handbuilding).

The starting point for developing recipes and methods is to identify something specific which you want the mould mix to be able to do. A ceramic equivalent to this could be developing a new clay body or glaze recipe.

'High temperature' mould mixture for float glass

You may need to make a mould into which to melt a soda lime-type glass (e.g. bottle or float glass), to withstand temperatures over 900°C (1652°F) for potentially long periods of time.

For a high-temperature mix, I suggest using at least 60% refractory by weight,

and a hard plaster. It is also advisable to make a dense mix, so use at least 1:1.6 – i.e. one litre of water to 1.6kg of dry material (see Chapter 10: List of Mould-mix Recipes, and *Particle packing*, Chapter 3: Understanding Ingredients). Reinforcement may also be necessary.

Spray application for fine detail

The mould-mix recipes for this piece (*Grey Flower*) are in Chapter 10: List of Mould-mix Recipes, p.98. The face coat was sprayed onto the wax model using a paint sprayer. This gave a very good-quality reproduction of the surface of the model, and meant little cold-working was needed. Subsequent coats or layers were built up with slight variations in mix. See *Grey Flower*, p.98.

Sand-casting in the kiln

Replicating the effects of sand-casting (see Chapter 1: Kiln-casting Glass) can

A ludo powder and sand mix supported by HTI bricks, packed with glass cullet.

The fired piece.

be done using dry mixtures of various combinations of materials:

Option 1 50% grog/50% plaster
Option 2 100% ludo powder
Option 3 50% sand/50% plaster
Option 4 50% sand/50% ludo

I see this as 'mouldless mould-making', as instead of wet-mixing to create a mould which takes and retains the shape from the model, you can free-form an open shape and texture spontaneously. This method is not suitable for undercut shapes or textures.

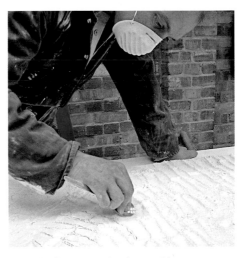

ABOVE: Tracing texture in plaster with a spoon.

BELOW: Glass slumped onto a textured bed of plaster.

Ceramic shell moulds

Ceramic shell is an alternative method of refractory mould-making using a non-plaster-based mix. The advantages are strong, lightweight moulds, while the disadvantages are its time-consuming application, and its tendency to stick badly to the glass, and the cost of the material.

EMILY BARBER

Emily Barber was one of the students graduating from the De Montfort University Design Crafts course in 2009, where I continue to teach as I write this. Emily's final project explored the challenging relationship of clay and glass fired together; clay and glass expand and contract at different rates during firing and cooling, which usually results in the two materials cracking apart. The individuality of Emily's approach was to develop her work around the idea of the mould being part of the final piece, not just a vehicle for its making.

Here are Emily's own descriptions of her work and her process:

'Drawing my inspiration from the human form, it was natural for me to explore the qualities I like about the body through sketching, casting and photography. Picking up on features of the torso such as folds of flesh and the way fingers sink into flab, I began to use the white stoneware like a skin, exploring touch by squeezing, scratching and stroking, so the subtle surface textures would be exaggerated when under the thick slumped glass.

'Experimenting with all kinds of mould-making for slumping and casting led me to using ceramic formers to slump my thick float glass. As I refined my techniques, I began to see the clay moulds as an integral part of the work, so developed my handbuilding skills and slumping cycles.'

All photos by Emily Barber.

The edge of a piece of float glass slumped onto clay.

The whole of the object.

Detail showing the texture of the clay and slumped glass.

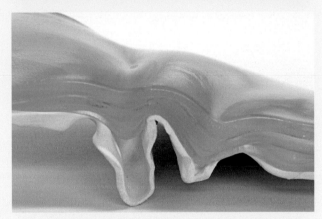

RIGHT: Detail of an edge.

BELOW: The whole finished object.

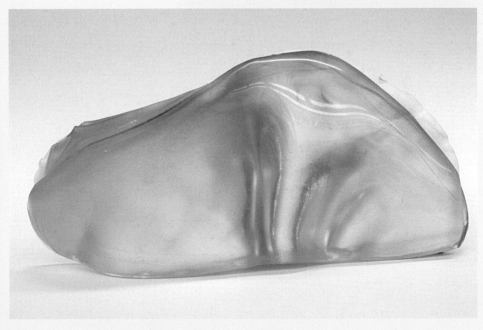

DEVELOPING YOUR OWN RECIPES AND METHODS

ANDREW GRAVES-JOHNSTON

Andrew Graves Johnston has worked for several years with mixed-media sculpture, and became interested in glass through the Bild-Werk Summer Academy in Frauenau, Germany. He has gone on to work with glass as one of his key materials, and uses a ceramic shell-type mould mix called Mold Mix 6 made by Zircar in the USA. It is a ready-mixed thixotropic refractory mould material which is an aluminosilicate (Al_2O_3. SiO_2) containing ceramic fibres (see Suppliers).

Andrew describes his work as follows:

'It was when I was introduced to kiln-formed glass four years ago that I found a medium that could truly convey the meanings I want to express.

Since then I have been working and experimenting with glass, inclusions and refractory moulds, pushing the limits of the materials. I am now one of very few artists in this country [UK] using Zircar (a ceramic-shell paste for refractory moulds) alongside traditional mould-making methods.

'At times I contrast found objects and mixed media with the perfect ephemeral properties of glass. Applying glass, with its historical connotations of luxury, to these objects allows me to reflect on today's culture from a new angle.'

Zircar Mold Mix 6 is a lightweight ceramic-shell mould material for casting glass. It allows the mould to breathe, so no sprues are needed. It can be used for hot-pouring, kiln-casting and slumping. Zircar is applied in thin layers using a medium-soft brush. Start at the top and move down the wax positive. Each layer should be dry before you start the next, and painting each layer in a different direction helps to bind the fibres in the Zircar together. Depending on the size of the mould, you will need about 6 to 7 layers, 0.5 to 1.5mm thick.

Once sufficient layers have been applied, the mould has to lose the wax and 'cure'. This is done with a blowtorch.

A wax model.

The wax model with the first layer of Zircar mix painted on.

The wax model with six layers of Zircar mix painted on.

Place the mould upside down on mesh over something like an old baking tin (to catch the wax) and start heating the mould from the reservoir end, allowing the wax to run out freely. Move the flame slowly up and around the mould until all the wax has gone. Any cracks or thin patches can be recoated and then torched again to cure. Coat the inside of the mould with a separator before loading with glass. Open moulds with no undercuts can be reused many times.

For further images of Andrew's work see Chapter 12: Fusing, Slumping and Pâte de Verre.

Using a blowtorch to burn out wax and cure the Zircar.

The cured Zircar mould.

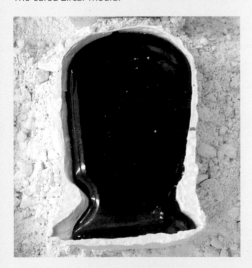

The fired Zircar mould with cast glass in it.

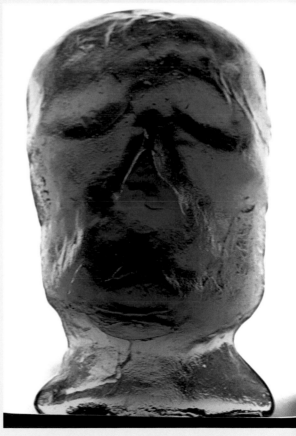

The finished piece.
Photos by Andrew Graves-Johnston.

FUSING, SLUMPING AND PÂTE DE VERRE

Given the scope of this book, it is only possible to touch upon these techniques in this chapter, but more information can be found in Further Reading.

Fusing, slumping and pâte de verre are all popular methods of making kiln-formed glass, and each of these techniques contains many permutations and possibilities.

Fusing

The basic meaning of 'fusing' is taking glass to a high enough temperature and for a long enough time for pieces to soften and then permanently bond together. It can be seen in fact as an opposite to refractory, which means withstanding intense heat. So the description fusing or fused glass can cover a wide range of effects and outcomes which may look radically different from one another.

There are many subtle differences and variations in this technique and a whole range of possible types and forms of glass which can be used to create a wealth of different effects (see Chapter 4: Types of Glass).

LEFT: *Red Ghost*, Andrew Graves-Johnston, 2010. Pâte de verre. Photo courtesy of the artist.

There are two main fusing techniques:

With *tack fusing* the glass pieces are just bonded together – softened but still distinct from one another both visibly and to the touch.

Full fusing is in essence a melt, but time at the top temperature is restricted so that the glass does not literally run away or pool. Not all form is lost, but there are no defined or protruding edges.

A piece of kiln-formed glass may have elements of both of these types of fusing within its making. See this chapter, p.113–4, for a description and a sequence of images of Sally Dunnett's work.

Fusing is often carried out without using a mould at all, but it can involve moulds, formers and various types of support in the kiln to create shape and surface.

An effective way to create textured glass surfaces is by using a prepared bed of ludo powder or plaster. A fired mould may be gently pushed through a fine sieve to produce an even layer of fine powder in which a texture or shallow relief can be gently created using a stick or your finger or found objects. Sheet glass or pieces of glass placed carefully over this texture and then fired will pick up the form and details of the texture and have a good-quality semi-polished surface on the

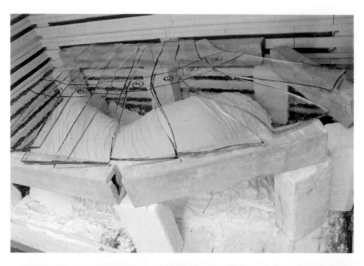

LEFT: *Sleep*, glass and mould in the kiln.

BELOW: *Sleep*, Max Jacquard, 2008. The finished piece, slumped float-glass, mould taken from life cast of human body. Photos courtesy of the artist.

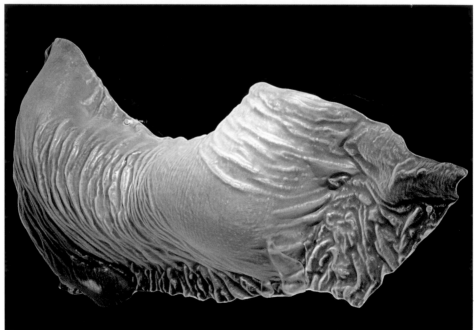

underside where the glass has been in contact with the ludo (see p.105).

This can be taken further, beyond firings to the point of real melting or a kiln version of sand-casting. A retaining wall or moat is created using kiln bricks and pieces of kiln shelf, and a deep bed of ludo or ludo and sand sieved into the space between them. This mix can then be packed and pressed into a shape which is then filled with pieces of glass and fired to melting point. After annealing and cooling, the underside of the glass will have a pleasant sandy texture.

Slumping

Bending or slumping glass is achieved by careful time and temperature control in a kiln. Bending happens at a lower temperature and needs to be watched carefully in order to capture just the right amount of movement, while slumping will happen at a higher temperature, when the glass is soft enough to relax and take up the form of a mould.

Glass can be successfully slumped over or into an open mould or through a cut-out shape called a drop ring. These are obtainable commercially, often made in ceramic, and will need to be coated with a release agent or bat wash before use (see Suppliers and Further reading).

You can make your own refractory moulds for slumping using simple methods and materials (see also Chapter 10: List of Mould-mix Recipes and Chapter 6: Mould-making Methods).

Slumping is often carried out after fusing, so that a design cut from pieces of coloured glass can be fused flat first to capture the pattern, and then slumped into or over a shape.

The following sequence shows steps for making a large fused and slumped glass dish.

1. Chart and cut strips of coloured Bullseye glass.

2. A circle of clear is glass cut and added to the design.

3. A fired disc of fused colour and clear glass.

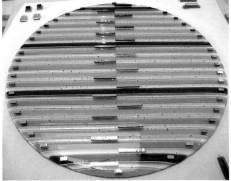

4. Small pieces of dichroic glass are added and the piece is fuse-fired for a second time.

FUSING, SLUMPING AND PÂTE DE VERRE

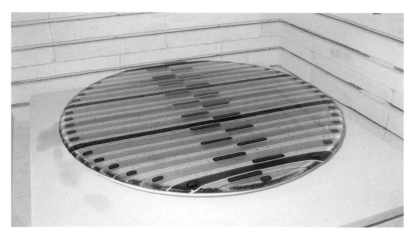

5. Glass on mould ready for third firing to slump it.

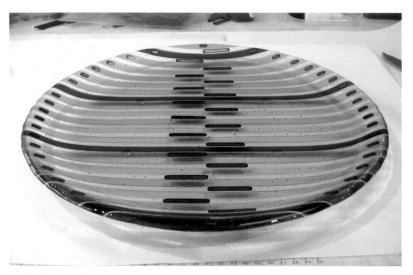

6. The finished slumped dish by Sally Dunnett. Photos by Sally Dunnett.

Pâte de verre

Pâte de verre translates into English literally as 'glass paste'. In French, the term pâte de verre is used to describe a variety of kiln-formed glass techniques, including what we describe as glass casting in English. As part of the range of kiln-formed glass techniques, pâte de verre is an ancient making method, and had a revival in France at the end of the 19th century. Artists and makers were looking for ways of making sculpture and objects where the material was the colour, not something which was treated or painted with colour. Beginning with this aspiration various well-known makers, artists and designers developed pâte-de-verre work, including Henri Cros, Françoic-Émile Décorchement, Gabriel Argy-Rousseau and Amalric Walter (see Further reading).

Bronze age pâte de verre beads, l: approx. 2cm (¾in). By permission of Bodrum Museum of underwater Archeaology, Turkey. Photo by Angela Thwaites.

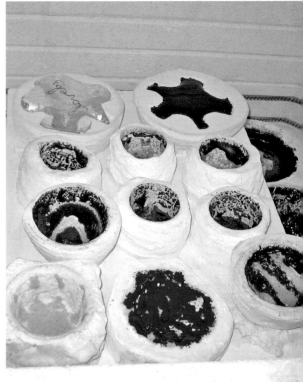

Pâte de verre in the kiln, showing how over-firing can make glass crawl down the sides of moulds. Photo by Angela Thwaites.

In English we usually use the term pâte de verre to describe a piece of kiln-formed glass where the level of fusion is controlled so that the granules are bonded together, but they do not entirely lose their texture or definition. So the texture remains slightly sugary, at least on one side of the piece. As described above, one of the main appeals of pâte de verre is the possibility it offers for colour placement. No other glass-making technique gives the same level of control over the placement of colour without movement within a piece.

Pâte-de-verre methods can be used to make hollow or solid pieces, depending on the form and effect required, and using a variety of grain or granule sizes, from fine glass powder to coarse granules or frit. In any case, the glass is usually mixed with water and a binder of some kind – either gum arabic or a commercially prepared fusing glue work well. Some practitioners use wallpaper paste. Only a small amount of binder is needed – just enough so that it will burn

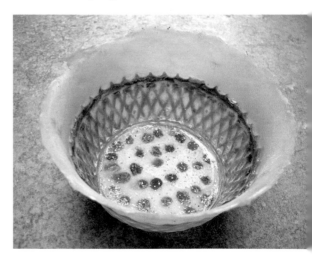

A tiny pâte-de-verre cup made using Optul powder approx. 8 cm (3 in) in diameter, by Angela Thwaites. Photo by Angela Thwaites.

FUSING, SLUMPING AND PÂTE DE VERRE

out without leaving any residue in the glass. The frit or powder is mixed with enough water and a few drops of liquid binder so that the texture is a wet paste that can be readily applied to the surface of the mould. Once the paste has been carefully applied, the mould can be put in the kiln and fired directly.

Refractory moulds for pâte de verre are often best made using the handbuilding method so that they follow the shape of the model very closely and are thin-walled, allowing heat in the kiln to penetrate quickly and evenly. This means that the paste is fused in situ but not melted or moved during the firing (see also Chapter 7: Handbuilding, and Chapter 10: List of Mould-mix Recipes). As access is necessary in order to apply the glass paste, the moulds you will make for this method will have an open side. Models can be made from a variety of materials, including wax, clay, rubber or found objects. Moulds for pâte de verre can also be made in pieces or parts.

I used Optul glass powder (see Suppliers) and applied the pâte de verre to the outside of a hollow, positive plaster-and-flint mould using fine brushes and a small flat wooden stick. The paste was about 2mm thick on the surface. It was fired to 700°C (1292°F) for 10 minutes. If over-fired, the glass can melt too much and slide down the sides of the mould.

I used a small plastic container with texture to make the mould for this sample piece of eggshell-thin pâte de verre (see bottom right, p.115).

Ghosts by Andrew Graves Johnston, 2010. Pâte de verre. A collage of many small seperate smaller pieces, each approx. l: 15cm (6in). Photo by Andrew Graves Johnston.

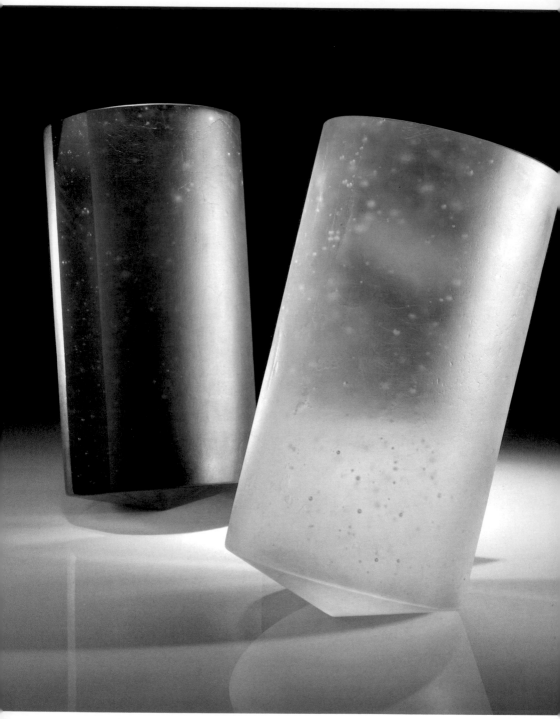

Mirror movement by Heike Brachlow, 2006. 16.5 x 33.5cm (6½ x 13¼in), and
16 x 30cm (6¼ x 11¾in). Photo by Simon Bruntnell.

SURFACES AND FINISHES

Description of cold-working processes

Working on the surface and finish of glass is usually called cold-working, as nearly all of the techniques are carried out 'cold', as opposed to the 'hot' shaping stages of kiln-forming or blowing. Cold-working processes include grinding, cutting, engraving, sandblasting and polishing. Cold-working encompasses a great range of techniques and processes, from a very light surface touch through to carving and totally reshaping.

Apart from sandblasting, where it is important that the glass is dry, practically all the other processes use either cold water or in some cases oil as a lubricant to keep the glass cool and to remove debris during the process.

Described below are basic suggestions for cold-working cast glass, while at the end of the book Further reading gives sources for more detailed information and other techniques.

Before casting

The character and aesthetic quality of any piece you make is defined by form, colour, transparency/opacity and surface. Therefore, thinking about the final surface you want on the glass *before* you even make the model, let alone the

Dos and don'ts for cold-working

Whatever you are working with, consider the following:

- Wear eye protection in the form of shatterproof goggles.
- Wear a waterproof apron, overalls and old clothing.
- Tie back and/or clip up long hair.
- Protect your hands with barrier cream or, in some situations, gloves.
- Choose sensible footwear that is strong enough for large-scale work, e.g. steel-toecap boots.
- For very wet work wear wellington boots and waterproofs.
- No jewellery or watch should be worn while working.
- Dry your hands before turning electric equipment on and off.
- Make sure you have no loose sleeves or items of clothing, as these could catch in the moving parts of the machine.
- Be aware of your posture and balance – don't stoop or stretch, and remember to distribute your weight evenly.
- Use a respirator or dust mask for airborne dust or vapour.
- Wear ear defenders when doing compressed-air tooling and some cutting/grinding.

- Have a first-aid kit close at hand, i.e. a minimum of eye bath and solution, sterile wipes, plasters and bandage.

- Maintenance is important – check and repair equipment and machinery on a regular basis.

- Take great care if you're working alone – plan and think in advance.

- Always work cleanly – wash your piece of work, your apron, hands and arms before and between each stage.

- Never contaminate fine grit or polishing materials with coarser materials, glass particles or other substances.

- Be systematic – it saves time.

- Check edges regularly and reinstate the bevel as it wears down.

- Always start with the finest grade of abrasive you think will do the job, and try it out first on a sample or on a small area to see the effect.

Darker colours show every mark, and if any mould mix sticks to a dark glass surface it can give a very dull, dusty look, which may not be easy to remove. Creating contrasting areas of surface can work well with light and colour to give a range of interesting optical effects (see Chapter 4: Types of Glass).

If you do *not* want to cold-work a surface, then this will affect your choice of material and method of making. In order to achieve the best results you should make informed decisions about mould-mix materials, recipes and types of glass before starting to make. Carefully considered choices can save a great deal of time and effort by:

- preserving a carefully made surface texture
- reducing the amount of finishing work to be done
- reducing the risk of mould and glass sticking to each other
- maximising the chances of a high-quality surface straight out of the mould.

If you do intend to cold-work and/or polish the entire surface of your casting, then the issue of mould mix sticking to the glass is less important, and the choice of materials you use for both model and mould is not so critical (see Chapter 6: Mould-making Methods, Chapter 10: List of Mould-mix Recipes, and Chapter 11: Developing Your Own Recipes and Methods).

mould, allows you to fully consider the options before committing.

There are many possibilities, and careful experimentation and sampling will give you a great repertoire of surfaces and finishes from which to select.

Decide what kind of surface you are aiming for: whether it is to be the same all-over finish, whether it will have contrasting shiny and matt areas (or somewhere in between), or whether it will be smooth or textured or even heavily textured.

You will also need to consider how the form and surface work with colour, or whether clear glass is a better choice.

After casting

Once you have de-moulded a piece, begin by removing sharp points and softening or bevelling sharp edges. This

can be done effectively by hand using either diamond hand pads or files or a piece of an old linisher belt, or by machine using a lathe or a linisher (see Glossary and Suppliers).

Once you can safely handle the piece, you should spend time thoroughly investigating the form and the surface. This is a highly personal exercise, as the history of the molten glass will give visible qualities which some makers strive for and others see as flaws or anomalies. Use a permanent marker or chinagraph pencil to mark up any areas which you decide need to be cold-worked. These may include flaws, flashing and bubbles.

De-moulding under extraction to prevent inhalation of mould mix dust.

Wet-working with machines

The main cold-working processes of cutting and grinding are abrasive and require lubrication. Excess glass is gradually worn away through contact with the abrasive surface or medium. The flow of the lubricant also helps to remove debris created by the working process and to keep the working surface of the machine and the glass clean enough so that you can see what is happening. A consistently dripping/slow-running water feed is usual for cutting and grinding processes. Each machine usually has a drainage system and a 'bosch' or trough to catch water and debris which can easily be cleaned out afterwards.

Set yourself up for working on a machine using the checklist above (p.119). Always take hold of the piece of glass in both hands and position yourself squarely and at the right height – not stooping or overreaching. If necessary find or make something stable

The piece cleaned and ready to begin cold-working.

on which to stand so that you have a comfortable and effective working height.

Stand where you have a good clear view of the contact point between the abrasive surface and the glass, and easy access to the off switch in case you need it. Keep a towel nearby and make sure your hands are dry when switching machines and power tools on and off. Many machines have an emergency

Max Jacquard's studio showing cold-working machines: angle grinder and flexidrive at wet benches and an assistant on the flat-bed grinder. Photo by Max Jacquard.

stop button which you can push with your knee or elbow if necessary. Adjust the water feed before starting work, so that it is flowing well enough to keep the working surface of the machine or tool and the glass wet.

If the water flow is too strong then it may spray everywhere, or grit may be washed off if using the flatbed grinder. If the flow is too weak then the work starts to dry out and heat friction may occur which can crack the glass, added to which the surface of the wheel or belt can become clogged with glass dust. If you continue to work dry, dust particles

may start to float around the workshop that are harmful if inhaled.

Removing excess glass using diamond saws

There may be excess glass at the point where it entered the mould from the reservoir, or several sprues if you have used more than one reservoir. These can be cut off using a diamond blade, or ground down if small (see pp.123–4 *Diamond saw, Flattening and lapping,* and *Cutting and polishing on a lathe).*

Diamond saw

In every case, make sure you do not cut into the form itself, as this can create extra work or even ruin the piece. If you are using a lap saw which runs automatically, then you will need to align the cut carefully when settling the work into the vice or clamp, and take account of the width of the blade. Shapes which are round or difficult to clamp or hold can be set halfway into a block of plaster. For ease of removal after cutting, it is important to make a 'soft' mix using less plaster than usually recommended.

Once the extra glass has been removed, the offcut can potentially be remelted, or utilised as a sample for trying out cold-working techniques and finishes (see Chapter 14: Recycling).

There are different types of diamond and lap saws, some of which have a bed which runs automatically, feeding the clamped work onto the blade. These saws often run with an oil lubricant. The clipper-type saws, where work is hand-guided or handheld, usually have water or an emulsion of oil and water fed onto the running blade. Wearing gloves is essential when setting up and handling pieces cut using oil-based lubricants.

Ways to finish the area from where you have removed the reservoir or sprue vary according to the shape of the object and the position of the cutting-off point.

Marking out

Using a permanent marker pen, cross-hatch the area of glass you are going to work on and let the ink dry. You may have to continue to work after the ink has been worn away, but this gives you

A flatbed grinder with a lathe in the background. Newspaper prevents any residual water dripping and rusting the surface.
Photo by Robert Taylor.

a guide as to where you are going and where you have been. As you work, wash and dry the piece, check it over, and replace the ink marks between the various stages of cutting and grinding.

Flattening and lapping

Creating and refining flat areas can be done using a flatbed machine and hand-lapping processes (see below). Flatbeds vary from large industrial to small-scale benchtop-mounted machines. Some flatbed grinders have cast-iron wheel heads which are used with abrasive in the form of silicon carbide grit or grain, while some grinders have diamond heads or magnetically attached diamond discs.

The piece of glass is held in both hands and gently lowered onto the moving surface. Rather than putting

the piece down vertically, I find it easier to approach from an oblique angle, as if landing an aircraft, and land the glass gently but firmly going with the direction of the moving wheel head. It is also easier this way to judge the distance and the moment of contact and therefore to start at the desired angle. Once the glass is in contact with the grinding surface, keep it level, keep it moving and glide in and out to and from the centre of the wheel, maintaining an even pressure with both hands. Either turn the piece around as you grind (if you are confident you will not wobble or change the angle) or take it off and put it on again if this is easier for you. When lifting on and off, make sure you are decisive but gentle, taking off and landing at the same angle as before. This way you avoid grinding facets or unnecessarily enlarging the ground area on your piece.

Work systematically through the grades (either grit or diamond),

cleaning, checking and re-marking the work between each grade. If you are using one machine for different grit grades, you will need to clean the machine thoroughly and completely between grades, or you can refine by hand-lapping.

Hand-lapping

This is a similar process to using the flatbed, but using your hands as the power source instead of the machine. It is normally used for refining a flat surface which has been coarse-ground on the flatbed, but it can also be used for complex and curved surfaces.

For flat lapping, take a sheet of float glass and prepare the surface by lightly and evenly sandblasting it. This creates better friction to start the hand-lapping process. Make sure all the grit and dust are washed off, and place the sheet of glass on a flat and even bench surface. I find a sheet or two of wet newspaper underneath helps to prevent slippage, but do not use a thick wad of paper as this is too soft and can create uneven pressure.

Working height is important – you need to be comfortable and not hunched over with your arms too high up the sides of your body. It is impossible to be too clean! Wash everything meticulously between grades of grit.

Place grit in the centre and add enough water to be able to spread it easily over the surface of the sheet of glass. Adding a couple of drops of detergent or liquid soap helps to break the surface

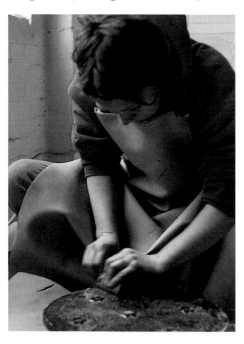

The author hand-lapping using a piece of sheet glass and fine grit to work around cast details. Photo from the author's archive.

tension of the water and means your piece of glass will move more easily and 'stick' less as you lap. Mix the grit, water and soap with your fingers and carefully place your piece of glass on top. Using both hands and an even pressure, push your piece round and round in slow firm circles. Some practitioners use a figure of eight instead, but I find this can create pressure and chipping on edges due to the push and pull, so I prefer to work in a circle. Every eight to ten circles you will need to bring the grit back again to the centre of the sheet. An old plastic card is useful for this – do not use your piece of work, as it is all too easy to chip the edges.

Hand-lapping is also useful for concave and complex curved surfaces which may have concave and convex undulations, like a landscape of hills and dales, and areas where access by machine is restricted or impossible. For lapping complex curved surfaces I use grit and water mixed as a slurry, and either metal or a scrap of glass cullet, preferably of a harder type than that of the casting (see Chapter 4: Types of Glass). This 'tool' needs to be shaped to the right profile, to achieve the maximum surface contact with the area to be worked, making the lapping as effective as possible. I usually set up the piece in a shallow tray to catch and reuse the slurry, and work with a circular motion, which is easiest on the hands and covers the area to be worked systematically.

NB: Hand-lapping is also a quick and effective way to flatten the base of moulds and reservoirs. Follow the description above, but use only clean water, no grit, and hand-lap for just a few 'rounds' on an already-sandblasted sheet of glass.

Cutting and polishing on a lathe

The lathe is a versatile piece of equipment as it can be used for cutting as well as polishing, for cutting there are several types of abrasive wheel which can be fitted to it. The action of the lathe is really an abrasive, grinding or carving one, but it is almost always called 'cutting'.

I still have carborundum, sandstone and synthetic wheels which can be reshaped using special diamond-ended tools. The stone wheels are fantastic for smoothing, and the surface is often beautiful to the touch, as well as to look at, without needing to be polished afterwards.

Nowadays most machines are set up for diamond-cutting, which is fast and efficient. Whichever system you use, it needs to be set up correctly, the speed set for the size of wheel, and the water flow adjusted accordingly, before work commences.

After a surface has been ground or cut and then refined, it can be bright-polished using pumice powder and then cerium oxide. Pumice polishing can be done on cork or felt wheels, and cerium only on felt. The polishing compound is mixed with water to a slurry, and applied using a clean piece of sponge to the moving surface of the wheel. Wheels may need to be dampened if they have not been used recently. NB: Polishing wheels need to be stored in a very clean environment. Wheels need air circulation during storage to prevent warping and mould forming.

I usually polish along the length of the piece, so that any light marks created by the texture of the wheel follow the line of the form. There is a range of grades of pumice available, so if you

want a super-refined surface finish you can use all of them in succession before cerium. Most practitioners use one grade only and then cerium to finish. The surface should be extremely bright and reflective after polishing, with no visible 'orange peel' effect from poor refining at earlier stages.

A bristle wheel can be used for brush-polishing with pumice to give a soft surface 'bloom'. This is a good way to remove the dry feeling of a sandblasted surface, and if prolonged brush-polishing is carried out a smooth and tactile finish can be achieved. Brush wheel and pumice can also be used to 'highlight' polished areas of a casting which stand proud of the main form or texture.

Linisher

A linisher has an abrasive belt set vertically and running in a loop with a water feed. It is used for edges and shallow convex curves. The abrasive belts have the same grading system as the 'loose' silicon-carbide grit, so work from the lowest number to the highest. Remember to wash the work as well as your hands, arms and apron between each change of belt, and then use the cork belt to polish.

Compressed-air tools and angle grinders

There are many types and styles of handheld compressed-air powered tools for studio or workshop use with a range of applications. They are a fast way to remove excess glass, and to carve and shape large-scale work where it is necessary to take the tool to the piece.

Diamond hand pads and files

Diamond pads and files are an extremely versatile option for cold-working by hand. They are relatively inexpensive and can last a long time if used correctly. Use cold or tepid water to work with diamond pads and files, and then wash and dry them between uses. Do not press the pads or files hard on points or edges, as the surface onto which the industrial diamond is bonded can become scored or damaged by sharp glass.

Diamond files are bonded onto steel. A range of sizes and grades is available, from large with a relatively coarse diamond, particularly useful for large-scale glasswork where taking the tool to the piece is preferable, through to needle files for small delicate work and access to tight curves and changes of angle.

Flexidrive engraver (Dremel)

There are several types of flexible-drive engraver on the market, including electric and compressed-air-powered. These range from the dentist pendant-drill type often favoured by jewellers and glass engravers for small-scale and fine work, and used with a variety of diamond burrs, through to larger-scale, more powerful types with a greater range of attachments and functions.

Sandblasting

Sandblasting has several useful applications, including removing surface flaws, decorating, softening, and changing a form by deep erosion and carving. It can also make a piece duller,

preventing light passing through the glass. Sandblasting dark-coloured glass can either soften or deaden, so always try it out on a sample first.

Hydrofluoric acid

This is a powerful acid for polishing and etching glass, but requires special storage conditions and equipment. **Its use is covered by strict health and safety regulations as it can be highly dangerous. I would not recommend it in a studio setup.** However, there are companies which acid-dip commercially, though the risk on kiln-cast glass is high, as the acid bath builds up heat which can result in cracking.

For more details about processes, equipment, and materials for cold-working see Suppliers and Further Reading.

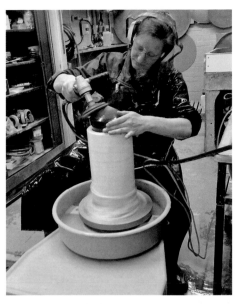

Heike Brachlow using a compressed-air angle-grinder to cold-work the base of a cast-glass piece. Photo courtesy of the artist.

Table of grit grades and diamond pad equivalents

Silicon carbide grit grades (mesh size)	Diamond pad approx. grade equivalent	Coarseness	Used for what?
80, 100, 180	Green (80–100)	Very coarse	Rough grinding and shaping, usually on flatbed machine
220	Black (180–200)	Coarse	Flatbed and/or hand-lapping; first stage of refining after very coarse work
320	Red (250–300)	Medium	Flatbed and/or hand-lapping, for refining; can be final matt surface
400	Yellow (500)	Fine	Hand-lapping, for further refining; can be final surface
600	Yellow (500)	Fine	Hand-lapping; pre-polish; can be final surface; translucent
800	Blue (800–1000)	Very fine	Hand-lapping; pre-polish; can be a final surface; extremely fine and translucent

Descriptions based on diamond hand pads from DK Holdings, UK (see Suppliers).

Eggy by Angela Thwaites, 2006. Made from recycled pieces of Gaffer glass cast through a reservoir with a narrow aperture to make the various colours flow together. Approx. l: 11cm (4¼in). Photo by Robert Taylor.

CHAPTER FOURTEEN

RECYCLING

Recycling and reuse applies to a number of materials and resources that can improve cost-efficiency and reduce waste.

Ludo
(See also Chapter 3: Understanding Ingredients)

Ludo is basically mould mix that has already been used and fired, and that can be used again either in chunks or as a powder. Ludo has several potential applications and benefits. Prepared by crushing and sieving, and used as a powder, ludo can:

- act as a modifier and a refractory in a mould mix
- act as a kiln-shelf primer or separator
- give improved particle packing, contributing to mould strength
- reduce shrinkage and cracking in a mould
- speed up the setting time of a mould mix
- release easily from, and give good-quality surface to, fired glass
- reduce material costs
- reduce waste

Ludo reduces costs as the material has already been used, and a cache of ludo can be continuously replenished and used again and again in mould mix as long as some new material is added each time.

Ludo can be used very effectively as an ingredient in a mould-mix recipe, provided it is combined with new plaster and new refractory material. Recipes using up to 30% ludo work extremely well for most refractory mould-making applications, and the fired mix is easily removed from the glass, giving a good clean surface. It is possible to use up to 50% ludo in some recipes, though this will give a soft-textured mix that is not suitable for lost wax, where long steaming can cause damage and in some areas dissolve the ludo completely.

Ludo powder can be used dry or wet instead of bat wash or shelf primer. If dry, the powder can be carefully sieved over a kiln shelf onto which moulds can be packed, and can also be used to make a fine, textured surface which releases well from the fired glass.

Combined with water, ludo makes a useful slurry with which to coat kiln shelves as an alternative to bat wash or shelf primer. It can be painted and either textured deliberately or smoothed down with your fingertips when it is nearly dry, to give a good surface onto which glass can be laid for fusing or moulds positioned for firing.

Chunks of ludo or large sections of fired mould mix can:

- act as support/filler in kiln-packing
- be used again and again in some situations
- be used directly in mould-making

Two flexible rubber bowls, the smaller one filled with water.

Left-over mould mixture poured into the larger of the two rubber bowls, with the smaller one filled with water and pushed into the centre of the mix to create a ring-shaped reservoir.

You can also use dampened pieces of ludo as a refractory filler, adding chunks directly to outer layers of mould mix while handbuilding or pouring moulds. (See also Chapter 7: Handbuilding, and *Troubleshooting* in Chapter 6: Mould-making Methods).

Reservoirs

Reservoirs made of mould mix can be reused but are often fragile after firing, so unglazed terracotta flowerpots are a good solution, particularly if you are using the same kind of glass or a compatible glass in similar amounts. (See also Chapter 6: Mould-making Methods, p.56).

Make sure the flowerpots are dust-free and that the aperture of the hole in the base is big enough to allow a good flow of glass into the mould. The size of the hole can be enlarged by filing with a round-shaped file or surform tool. If the

flowerpot is to stay in the kiln through the entire firing process, then it should be raised up above the opening in the mould on bat-washed kiln props or chunks of ludo. If this is not done, any residual glass will stick the pot to the top of the mould, making it very difficult to separate them after cooling.

Flowerpots can be removed during firing after all the glass has melted and run into the mould. Ann Robinson (New Zealand) makes a plug for the hole in the bottom of the pot, which she pulls out once the glass has melted, letting the stream of molten glass into the mould in one go. This makes for a clear, bubble-free casting and the pot can then be removed from the kiln completely, so there is no danger of it sticking either to the glass or the top of the mould. This method also puts less strain on the mould as it shortens the time the mould has to endure the full weight of the glass and reservoir, reducing the risk of mould cracking or failure.

The ring-shaped reservoir after the rubber bowls have been carefully removed. This can also be carefully shaped or carved to hold more glass.

Ceramic fibre

Ceramic-fibre blanket and board can be reused in a number of ways. Keep any ceramic-fibre material in a plastic crate with a lid, and handle it carefully both before and after it has been fired, as it gives off microscopic fibres which are harmful if breathed in (see Chapter 3: Understanding Ingredients). It is more fragile and brittle after firing so needs to be gently removed and stored for reuse. **always wear a dust mask and gloves to handle it.**

Ceramic fibre can be used in mould-making, for making reservoirs and in kiln-packing. Pieces of ceramic-fibre board can be reused to construct box-shaped moulds in conjunction with mould mix. (See *The Art and Technique of Pâte de Verre* in Further Reading.)

Clay

(See also Chapter 5: Model and Master Mould-making.) Clay can be kept and reused time and time again over a period of years. It needs to be kept in an airtight bucket or lidded container, as free as possible from bits of plaster, wax, etc., and checked regularly to prevent drying out. If clay does dry out or become too contaminated with other materials, it can be broken up and any contaminants removed, then reconstituted with water and wedged back very easily into usable condition.

Wax

Wax can be recycled and reused any number of times providing it is not overheated or boiled during melting. Wax can be collected while steaming out a mould, dried out and then remelted.

Wax melts more easily from smaller pieces (unlike glass!), so I made a gelflex mould from a baking tin for buns or

Small patties of wax made in a gelflex mould taken from a baking tin.

muffins, to create small patties of wax for reuse. Wax also cools and sets much faster in small amounts, so you can recycle and then reuse it more quickly.

Gently re-melt the wax in a clean pan either on a low heat, or using a bain-marie – a dry container with the wax in it placed over a second pan of hot water for gentle cooking. Once the wax has melted, leave it to stand for a few moments to ensure that any detritus (crumbs of plaster, mould mix, clay, etc.) has sunk to the bottom along with any water still present. Take a funnel, or you can use the cut-off neck of a mineral-water bottle, and stretch an old pop sock or a piece of an old pair of tights over the narrow end. Let the wax stand and cool for a moment, so there are no bubbles in it. Before it starts to thicken, carefully pour the wax through this funnel filter into a rubber or dampened plaster mould and let it set. The water and the detritus will be in the bottom of the pan, so pour this into a separate mould or onto newspaper if it is no longer usable. The pan can be wiped out with old newspaper when it has cooled a little bit

but the wax residue is still soft enough to be removed. I recommend having separate pans for melting and recycling, to ensure the highest level of purity in the wax you use for model-making.

Glass

Most types of glass can be recycled or reused. In every case, having as much information as possible about the properties of the glass – particularly the melting and annealing temperatures – will ensure the best results (see Chapter 4: Types of Glass).

When we talk about recycling glass, most people think of bottles, but this is probably the least energy-efficient material to recycle. Bottle glass is one of the hardest types of glass, so melting it can be difficult as it requires a high temperature (approx. 1100°C/2012°F) if it is to yield transparent results. This also means that the mould needed to withstand this temperature must contain highly refractory material and may need to be reinforced and supported in the kiln so that it does not crack during the firing. It is possible, however, to get good results with bottle glass on a very small scale by using a special refractory box inside a microwave oven (boxes are available from Pearsons Glass, see p. 142).

To re-melt glass, make sure it is very clean. This may mean sandblasting the surface to remove any contaminants, old mould mix or discoloration. A sandblasted surface may lend veiling to a casting, but this can add to the character

Bronze Age billets of glass to be recycled. Each billet, dia: approx. 12cm (4¾in). Bodrum Museum of Underwater Archaeology.

and visual depth of a piece of work.

Do not mix glasses unless you are completely sure of their compatibility (see Glossary).

Glass in various forms – a found object, a discarded kiln-formed piece or a remnant – can be cleaned, crushed and sieved to give various sizes of grain for pâte-de-verre projects (see Chapter 12: Fusing, Slumping and Pâte de Verre).

Rubber

Gelflex rubber is manufactured to be re-melted and re-used. It must not be overheated or it will burn giving off terrible fumes and ruining the material. Old gelflex rubber models and moulds can be re-melted. Clean by washing and drying and then cut into small cubes or chunks that will melt easily. This can be done in a thermostatically controlled melting pot or for small amounts in a microwave oven in a Pyrex jug. Start with a couple of handfuls of cubes and heat on medium power. Stir every 2 or 3 minutes to redistribute any lumps, and keep adding more pieces and melting again. You may need to increase the heat a little as the rubber begins to liquefy. Allow the molten gelflex to stand and rest before pouring so that any bubbles rise to the surface (see Chapter 5: Model and Master Mould-making, pp.45–7).

Old models and moulds made from cold-cured silicon-type rubber which would otherwise be thrown away can be reused, saving on new material. Wash clean and dry the rubber material and cut it into strips or chunks. These can then be incorporated or embedded into 'new' liquid silicon as a filler.

Heat and energy

If you place newly made refractory moulds above or near a kiln during firing, the heat the kiln gives out will speed up the drying process. This saves on time and potentially on energy usage where moulds would otherwise be kiln-dried (see Chapter 9: Mould-drying, Kiln-packing and Firing). Using a microwave oven for small-scale melting of gelflex, glass (in conjunction with a special refractory box, see Suppliers) and wax uses less energy than other conventional electric-powered methods. Good ventilation is necessary in all cases.

Water

Water is a valuable resource, and the quantity used in even a small workshop should not be underestimated. Simple solutions like not leaving the tap running and rinsing tools and equipment in a bucket so that water can be used more than once will reduce consumption over time.

Harvesting in a rainwater butt from your workshop roof provides a supply of water which can be used for a range of cleaning jobs, e.g. mopping floors and washing out buckets.

Silicon carbide

This highly refractory material theoretically presents a potentially interesting mould-mix component. It may be a more economically viable refractory alternative if carefully reclaimed and recycled after being used as an abrasive when cold-working glass.

FURTHER READING

Bloch-Dermant, Janine, G. *Argy-Rousseau: Glassware as Art*, translated from the French by Marian Burleigh-Motley (London: Thames & Hudson Ltd, 1991).

Bray, Charles, *The Dictionary of Glass: Materials and Techniques* (London: A&C Black; USA: University of Pennsylvania Press; Australia: Craftsman House; 1996).

Bray, Charles, *Ceramics and Glass: A Basic Technology* (England: Society of Glass Technology, 2001).

Corning Museum of Glass, *New Glass* (exhibition catalogue) (Corning Museum of Glass, USA, 1979).

Cummings, Keith, *Techniques of Kiln-formed Glass* (London: A&C Black; USA: Axner Co., Inc.; Australia, Craftsman House; 1997).

Cummings, Keith, *Amalric Walter* (exhibition catalogue) (UK: Broadfield House Glass Museum, 2007).

Cummings, Keith, *Contemporary Kiln-formed Glass: A World Survey* (London: A&C Black; USA: University of Pennsylvania Press; 2009).

Delpech, Jean-Pierre and Figueres, Marc-Andre, *The Mouldmaker's Handbook* (UK: A&C Black Publishers, 2004).

Doremus, Robert H., *Glass Science* (2nd edn) (USA: John Wiley & Sons, Inc., 1994).

Frantz, S., Buechner, T., Petrova, S., and Setlik, J., *S. Libenský, J. Brychtová: A 40-year Collaboration* (in conjunction with exhibition at Corning, USA and Germany: Prestel-Verlag; 1994).

Frantz, S., Klasova, M., Setlik, J., *Stanislav Libenský Jaroslava Brychtová Karolinum 2000* (in conjunction with an exhibition at the Karolinum, Prague) (Czech Republic, Brno: printed by Tiskarna Didot, spol s.r.o., 2000).

Frantz, S., *Particle Theories: International Pâte de Verre and Other Cast-glass Granulations* (Museum of American Glass, Wheaton Village, USA, 2005).

Fraser, Harry, *The Electric Kiln: A User's Manual* (London: A&C Black; USA: Axner Co., Inc.; Australia, Craftsman House; 1995).

Halem, Henry, *Glass Notes: A Reference for the Glass Artist* (USA: Franklin Mills Press, 1993).

Hamer, F. & Hamer, J., *The Potter's Dictionary of Materials and Techniques* (London: A&C Black, 1997).

Kervin, J. & Fenton, D., *Pâte de Verre and Kiln Casting of Glass* (USA: Glasswear Studios, 1997).

Klein, D., *Glass: A Contemporary Art* (London: Collins, 1989).

Lundstrum, Boyce, *Glass Casting and Moldmaking (Glass Fusing, Book 3)* (USA: Vitreous Publications, 1989).

Maloney, F.J., *Glass in the Modern World* (London: Aldus Books, 1967).

McGregor, Lani and Schwoerer, Daniel, *Contemporary Kiln-formed Glass* (USA: Bullseye Glass, 1992).

McLellan, George W. & Shand, E.B., *Glass Engineering Handbook* (3rd edn) (USA: McGraw-Hill Book Co., 1984).

Özet, Aynur, *Sparkles From The Deep, Glass Vessels of The Bodrum Museum of Underwater Archaeology* (Turkey: Bericap Kapak Sanayi Ltd, 2000).

Paul, A., *Chemistry of Glasses* (London: Chapman & Hall, 1982).

Petrova, Dr S., *Czech Glass* (Gallery, Prague, Czech Republic, 2002).

Petrova, Dr S., *Czech and Slovak Glass in Exile* (exhibition catalogue) (Moravian Gallery in Brno and Kant, 2007).

Reynolds, Gil, *The Fused Glass Handbook* (USA: Hidden Valley Books, 1987).

Rhodes, Daniel, *Clay and Gazes for the Potter* (rev. edn) (UK: Pitman, 1979).

Ricke, H. & Frantz, S., *The Glass Skin* (exhibition catalogue) (USA: The Corning Museum of Glass, 1999).

Singer, F. and Singer, S.S., *Industrial Ceramics* (London: Chapman & Hall Ltd, 1963).

Stewart, Max, and Cummings, K., *The Amalric Walter Research Project* (UK: University of Wolverhampton, 2007).

Tokyo Glass Art Institute, *The Art and Technique of Pâte de Verre* (Tokyo Glass Art Institute: Nissha Printing co. Tokyo, Japan, 1998).

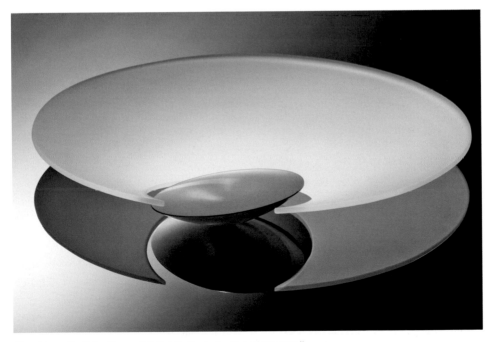

Float Form No.7, by Steven Whitehill. Photo by Simon Bruntnell.

GLOSSARY

annealing – a carefully controlled cooling process to prevent the forming of permanent stress in glass. Glass is a poor conductor of heat. Thin glass loses heat quickly, and thick glass slowly, which means that to anneal a casting with variable thickness, it is necessary to calculate the annealing cycle according to the thickest part of the form. It is also necessary to take the mould thickness into account as well, as this too needs to lose heat.

annealing cycle – the period of time during a kiln firing where cooling is programmed and carefully controlled (which may last several months if a particular glass object in the kiln is of particularly large dimensions).

annealing point – the temperature at which stress in glass is relieved and at which to begin the annealing cycle. The actual temperature of the annealing point is specific to each glass. Keith Cummings defines the annealing point as 'holding the glass at the transformation point (actual annealing point +5°C/9°F) for a given length of time depending on the weight and thickness of the material'.(See also *transformation temperature*).

annealing soak – holding the kiln at a particular temperature, in order for the temperature of *everything* in the kiln to equalise, before beginning slow, controlled cooling.

bat wash – also called kiln wash or separator, this is a refractory slurry containing china clay, alumina and water, obtainable ready dry-mixed, applied, usually by brush, to kiln shelves, props and sometimes mould surfaces to prevent sticking of glass (or ceramic glazes).

binder – a component in mould mix, usually a type of plaster, which takes and retains the mould shape and holds together other component materials in the mix.

blow moulds – moulds for blowing glass into.

cane tests – a method of establishing the annealing point of a particular glass by heating a pencil-thick 45cm (18in) long rod of the glass in a kiln at a specific temperature and for a specified time.

castable refractories – commercially produced material which can take and retain a shape. Used to build kilns and furnaces.

china clay – a fine white clay, also called kaolin, from the Chinese region of Kao Ling where the clay is found.

coefficient of expansion – (abbr. COE) a value – e.g. 96 – given to a glass (or other material) which expresses the relative tendency of the material to expand and contract when being heated and then cooled. Attempting to melt together glasses whose coefficients of expansion are different from each other will probably result in cracking, as each material will expand and then contract at a different rate (see also compatibility).

cold-working – processes used to refine the form and surface of glass after

production – e.g. sawing, grinding, lapping, polishing – all done without the application of heat, using water or oil as a lubricant. Cold-working may be done by hand methods or using tools and machinery.

compatibility – only glasses having the same chemical composition can be said to be compatible, which means they can be fused or melted together successfully. Glasses with different chemical compositions have different physical properties and different coefficients of expansion, and are usually incompatible – i.e. if melted together they will crack, either immediately or sometimes subsequent to firing and cooling, and in extreme cases will fall apart completely.

core casting – refers to methods for casting a hollow form, or one shape inside another shape.

cottling – sometimes called coddling, this is a method for constructing retaining walls or a surround around the model to be invested. Common materials for this process are wood, clay, linoleum, polypropylene sheeting and sheet glass.

crash cooling – a process of reducing temperature quickly by opening vents and/or the door in the kiln. It is usually done to limit devitrification and to save time and energy during firing.

cullet – broken pieces of glass, remains from studio/factory production processes, which can be re-melted and reused, either for glassblowing or for kiln-forming.

devitrification – the growth of crystals on/in glass, its literal meaning is 'becoming not glass'. Devitrification can cause problems when kiln-forming glass, as crystals are resistant to re-melting, and it may also lead to problems of incompatibility with the main body of glass.

face coat – an initial layer of mould mix applied directly to a model, either by pouring, brushing or spooning on, before subsequent layers of mould mix are applied. A different recipe of mix, using finer materials or incorporating a release agent to prevent sticking, can be used for a face coat. This can be backed up with coarser layers, using cheaper materials, to provide mould strength. The use of a face coat ensures accurate reproduction of detail from a model.

fettling – a method of carefully cleaning off seam lines or perfecting flaws.

Fiberfrax – a trade name for a type of ceramic fibre in 'paper'/sheet or blanket form.

firing cycles/schedules/curves – the actual time periods of the firing, set by the practitioner according to the glass, form and scale of object or mould. Usually carried out by an electronic/computerised control unit or programmer attached to the kiln.

flashing – 'fins' or 'frills' of glass attached to the main casting, formed by molten glass which has seeped into cracks in the mould during firing.

float glass – mass-produced sheet glass (e.g. window glass) made by a process whereby molten glass is floated on a massive bed of molten tin.

friable – easily crumbled.

frit – glass in fine granular form, often made by heating and then dropping glass into cold water to aid in its breakdown into fine granules. Can be purchased readymade to a particular mesh size for pâte-de-verre work.

goes off – when plaster is being mixed it starts to thicken or 'go off', as it reacts chemically with the water.

hydrostatic pressure – pressure exerted by a fluid at rest due to the force of gravity (molten glass).

investment moulds – moulds of a plastic (often pourable) mixture of materials that can cover, take and keep an accurate detailed shape from a model. The investment mould can be easily separated from the model, fired and filled with molten metal or glass.

island method – a process of judging, by eye, the quantity of plaster (or mould mix) to be added to a given amount of water. The dry material is sprinkled into the water until a cone-shaped 'island' of material is visible just under the surface of the water. This is allowed to absorb the water before mixing. Experimentation is necessary to develop accuracy using this method.

lapping/lap – a method of grinding or smoothing the surface of a glass object, on a horizontally mounted cast-iron or steel wheel with silicon-carbide grit and water slurry applied between wheel head and object, or on a diamond surface.

 The glass object is held by hand and moved over the surface of the wheel to evenly grind or smooth the contact area of the object. This process may be done by hand, the slurry applied to a sheet of glass or piece of metal, and the object turned in a circular motion with constant, even hand pressure, which will slowly but accurately lap the surface of the object by abrasion.

linisher – a machine with a moving abrasive belt and water lubrication for cold-working glass.

mesh size – the measure of particle size. This is based on the size of particles passing through a wire mesh (usually a sieve), which is numbered according to the number of 'openings' per linear inch or centimetre.

micron – a unit of length which is one thousandth part of a millimetre.

modifier – a mould-mix component which changes the behaviour of the entire mixture towards a desired outcome.

mould-melted – another way of describing kiln-cast glass.

mould mix – a mixture of materials specially prepared for investment mould-making for kiln-forming glass.

nichrome wire – nickel chromium wire is used to make kiln elements, so it is very durable under heating and cooling.

packing/molecular packing – the fitting together of particles of different sizes to form an interlocking matrix within a mould-mix body, which improves density and adds strength to a mould.

pâte de verre – in the UK this is taken to mean a technique where finely crushed glass (60–80s mesh) is prepared in a water and binder paste to permit precise or selective placement into a refractory mould, which is then fired in order to fuse the glass together without displacing it. In France the term is used to include a wider range of kiln-cast glass techniques.

piece mould – a mould made around a model in separate parts or pieces which, when removed, fit accurately together. This method is normally used when the original model is

made of a rigid material, e.g. plaster, and the mould is also plaster. This method can also be used for making refractory investment moulds in conjunction with jacket layer(s) of additional mould mix.

props – hollow, often cylindrical, stackable fireclay elements for supporting shelves in a kiln.

pyrometer – a device for measuring the temperature in a kiln.

pyrometric cones – small triangular cones made of ceramic material designed to bend at specific temperatures. They are placed in an easily visible part of the kiln so that the temperature can be closely monitored during firing.

quartz – SiO_2, the most common form of the mineral silica, existing in two forms: alpha, which only exists below $573°C$ ($1063°F$), and beta, which only exists above this temperature. Quartz is found in the form of crystals, some of which are large and milk-white. When crushed it is a source of fine white sand, used in the making of glass and refractory moulds for glass.

quartz inversion – when temperature rises, the crystals in quartz rearrange themselves, and at $573°C$ ($1063°F$) there is a change from alpha to beta quartz. This change is marked by a slight increase in volume (approx. 2%), but this is reversible – the quartz contracts again upon cooling and reverts to it's alpha form below $573°C$ ($1063°F$).

ramp – a distinct section or segment of a firing schedule or program.

refractory – a substance resistant to the action of intense heat.

release agent – a material which may be applied as a very thin surface layer to aid separation between model and mould.

reservoir – a refractory addition to the top of a mould, often cup-shaped, to contain cullet, chunks or billets of glass before firing. Reservoirs can be made in mould mix as part of the investment mould, or separately; or they can be made of fibre board/ blanket. Some practitioners use clay flowerpots.

runners – narrow channels in the body of the mould mix through which glass may flow to fill the cavity of the mould. Term used in metal casting.

sand-casting – hot pouring of molten glass or metal into a shape or impression pressed into specially prepared sand, which acts as a mould. The glass needs to be annealed afterwards to prevent cracking.

separator – an agent or material which allows model and mould to separate easily without sticking – e.g. soft soap used on plaster, or bat wash on a kiln shelf or ceramic mould.

shellac – an organic varnish used to seal the surface of porous materials, e.g. plaster, and to aid model and mould separation.

silica – the fundamental oxide of glass (silicon dioxide/SiO_2), also used in investment mould-making and important as a potter's mineral for making clays and glazes. Occurs naturally as quartz, flint and sand. It has a melting point of $1710°C$ ($3110°F$).

silicon carbide – a synthetic material produced from heating mixtures of sand, petroleum coke, sawdust and salt. It is used in cold-working glass

as an abrasive, and is also a refractory used for making kiln furniture.

soak/dwell – to hold a kiln at a set temperature for a given period of time in order to achieve a particular result, i.e. to melt, slump, fuse or anneal glass.

softening point – the temperature at which glass sags quickly under its own weight.

soft soap – a separator used particularly between plaster models and moulds.

spalling – pieces of mould material cracking and falling off during firing.

sprue – a name for feeder channels in casting.

strain point – the lowest point of an annealing cycle below which no permanent stress can be introduced into the glass, although it is still susceptible to thermal shock below this point.

suck in – a surface flaw in a glass casting which has the appearance of a dimple or shallow pit, this develops during crash cooling as areas of molten glass cool more quickly than others and draw back, or 'suck in', from the mould surface.

talc – a soft whitish mineral, largely made up of magnesium silicate. Certain varieties contain traces of asbestos.

thermal conductivity – the ability of a material to allow heat to pass through itself.

thermal shock – an effect caused by rapid reduction (or increase) of heat, e.g. by opening the door of a kiln, it may lead to stress fracturing of glass or contraction of materials in a mould mix, resulting in cracking of moulds.

transformation temperature – a narrow temperature range above which glass starts to behave like a liquid, this is a result of raising the temperature of the glass to the point where its tendency to flow is dramatically increased.

undercuts – a model- and mould-makers' description for part of a form which turns in on itself, or is hooklike in section.

veiling – soft flowing patterns, lines or trails of very fine bubbles in cast glass, looking like the Milky Way.

venting – also called 'gating', a process of making airways in a mould by using organic material – e.g. wooden cocktail or satay sticks, drinking straws, cotton threads – which will burn out during firing to leave a clear airway through the mould material.

viscosity – a material's resistance to flow. High viscosity means material is very stiff, while low viscosity means material flows easily.

water displacement – a method of estimating the volume of glass needed to fill a mould.

wheel-cut – abrasive carborundum, diamond or sandstone wheels are vertically mounted on a lathe and used, with water as a lubricant, to grind, cut or smooth glass.

wicking – tiny holes or channels along which moisture may travel more easily through the mould body from inside to outside achieved by including fibres in the mix.

zircar/luminar – Mold Mix 6 is a ceramic shell-type mould mix made in the USA. It is a ready-mixed thixotropic refractory for application in layers with a brush.

SUPPLIERS

UK

ACC Silicones Ltd
Amber House
Showground Road
Bridgwater
Somerset TA6 6AJ
Tel: +44 (0)1278 411400
Fax: +44 (0)1278 411444
www.acc-silicones.com
Gelflex and silicon rubbers.

Alec Tiranti Ltd
Shop:
27 Warren Street
London W1T 5NB
Tel: +44 (0)20 7380 0808
Fax: +44 (0)20 7380 0808
Wax, alginate, silicon rubbers, latex, melting pots for Gelflex rubber, sculpture tools.

Mail Order & Showroom:
3 Pipers Court
Berkshire Drive
Thatcham
Berkshire RG19 4ER
Tel: +44 (0)845 123 2100
Fax: +44 (0)845 123 2101
www.tiranti.co.uk
www.tiranti.com

Capital City Abrasives
Unit 3, Carr Network Centre
Millennium Way
Newcastle-under-Lyme
Staffordshire ST5 7XE
Tel: +44 (0)844 8840120
www.ccabrasives.com
Silicon carbide grit.

Creative Glass UK
12 Sextant Park
Medway City Estate
Rochester
Kent ME2 4LU
Tel: +44 (0)1634 735416

Fax: +44 (0)1634 295734
www.creativeglassshop.co.uk
Glass, materials, kilns, tools, books, equipment and courses.

D.K. Holdings Ltd
Station Approach
Staplehurst
Kent TN12 0QN
Tel: +44 (0)1580 891662
www.dk-holdings.co.uk
Diamond and abrasive products for glass and stone.

The Fibreglass Shop
197 High Street
Brentford
Middlesex TW8 8AH
Tel: +44 (0)208 568 1645
www.thefibreglassshop.co.uk

Gaffer Glass UK Ltd
Unit 36, Limberline Spur
Estate
Hilsea
Portsmouth PO3 5DX
Tel: +44 (0)23 9267 7674
www.gafferglass.co.uk
Casting glass.

Gold Star Powders
(a division of Goodwin
Refractory Services Ltd)
Spencroft Road
Newcastle-under-Lyme
Staffordshire ST5 9JE
Tel: +44 (0) 1782 66 36 00
Fax: +44 (0) 1782 66 36 11
www.goldstarpowders.com
Gold Star Crystalcast investment mix.

H.S. Walsh
Beckenham Head Office:
243 Beckenham Rd
Beckenham
Kent, BR3 4TS

Tel: +44 (0)20 8778 7061
Fax: +44 (0)20 8676 8669
Pumice powder, cerium oxide, diamond burrs, etc.

Hatton Garden Showrooms:
44 Hatton Garden
London EC1N 8ER
Tel: +44 (0)20 7242 3711
Fax: +44 (0)20 7242 3712
www.hswalsh.com

Kilncare
The Kiln Works
907 Leek New Road
Baddeley Green
Stoke-on-Trent
Staffordshire ST2 7HQ
Tel: +44 (0)1782 535915
Fax: +44 (0)1782 535338
Email : sales@kilncare.co.uk
www.kilncare.co.uk
Electric kilns for glass.

Lapmaster International
Lee Mill Industrial Estate
Ivybridge
Devon PL21 9EN
Tel (UK): (0)1752 893191
Tel (international): +44
(0)1752 893191
Fax (UK): (0)1752 896355
Fax (international): +44
(0)1752 896355
www.lapmaster-abrasives.
co.uk
Black and green silicon carbide, cerium oxide.

Metrodent Ltd
Lowergate Works
Lowergate Paddock
Huddersfield
West Yorkshire HD3 4EP
Tel: +44 (0)1484 461616
Orderline: +44 (0)1484
466700

www.metrodent.com
Dental waxes.

**Milton Bridge Ceramic
Colour Ltd**
Unit 9, Trent Trading Park
Botteslow Street
Hanley
Stoke-on-Trent
Staffordshire ST1 3NA
Tel: +44 (0)1782 274229
Fax: +44 (0)1782 281591
Email: djb@milton-bridge.
co.uk
www.milton-bridge.co.uk
Ceramic materials.

Pearsons Glass Ltd
9–11 Maddrell Street
Liverpool
Merseyside L3 7EH
Tel: +44 (0)151 207 2874
www.pearsonsglass.com
*Sheet glass – Artista, Uroboros,
Spectrum; glass enamels
and other materials for
glassmakers.*

Plowden and Thompson
Dial Works
Stewkins
Stourbridge
West Midlands DY8 4YN
Tel: +44 (0)1384 393398
Fax: +44 (0)1384 376638
Email: sales@plowden-
thompson.com
www.plowden-thompson.com
*Manufacturers and suppliers of
glass, courses.*

Potclays Ltd
Brickkiln Lane
Etruria
Stoke-on-Trent
Staffordshire ST4 7BP
Tel: +44 (0)1782 219816
Fax: +44 (0)1782 286506
Email: sales@potclays.co.uk

www.potclays.co.uk
*Ceramic supplies, e.g. molochite,
flint, plaster, silica sand.*

Poth Hille & Co. Ltd
Unit 18, Easter Industrial
Park
Ferry Lane South
Rainham
Essex RM13 9BP
Tel: +44 (0)1708 526 828
Fax: +44 (0)1708 525 695
*Manufacturers and suppliers
of waxes.*

Potterycrafts
Head Office:
Campbell Road
Stoke-on-Trent
Staffordshire ST4 4ET
Tel: +44 (0)1782 745000
Fax: +44 (0)1782 746000
Email: sales@potterycrafts.
co.uk
www.potterycrafts.co.uk
*Ceramic materials and
equipment.*

Scangrit
Eastfield Road
South Killingholme
Grimsby
NE Lincolnshire DN40 3NF
Tel: +44 (0)1469 574715
Email: sales@scangrit.co.uk
www.scangrit.co.uk
Silicon carbide grit.

Special Plasters
Unit 2, Benson Road
Birmingham B18 5TD
Tel: +44 (0)121 515 1555
Email: info@specialplasters.
co.uk
www.specialplasters.co.uk
*A wide range of plasters and
SRS investment.*

Mainland Europe

Stipglas
Utrechtstraat 6-10
5038 EL Tilburg NL
Netherlands
Tel: +31 (0)13 53 56 186
stipglas@stipglas.com
www.stipglas.com
*Glass, materials, books and
courses.*

USA

**Zircar Refractory
Composites, Inc.**
PO Box 489
Florida, NY 10921
Tel: +1 (845) 651-2200
Fax : +1 (845) 651-1515
Email: sales@zrci.com
www.zrci.com
Zircar Mold Mix 6.

Bullseye Glass USA
Online shop only.
Tel: (toll free) 888.220.3002
www.bullseye.com (USA)
(They also ship to other
countries, contact sales@
bullseyeglass.com for
information.)

INDEX

INDEX